ROYAL ACADEMY ILLUSTRATED 2006

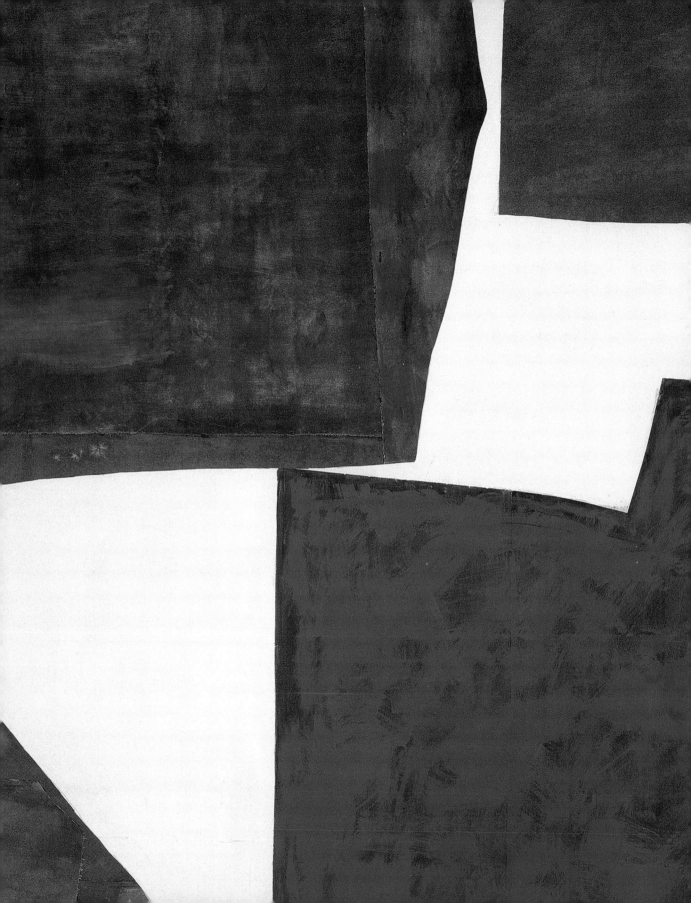

A selection from the
238th Summer Exhibition

Edited by Alison Wilding RA

ROYAL ACADEMY ILLUSTRATED 2006

ROYAL ACADEMY OF ARTS

SPONSORED BY

Insight
INVESTMENT

HBOS plc

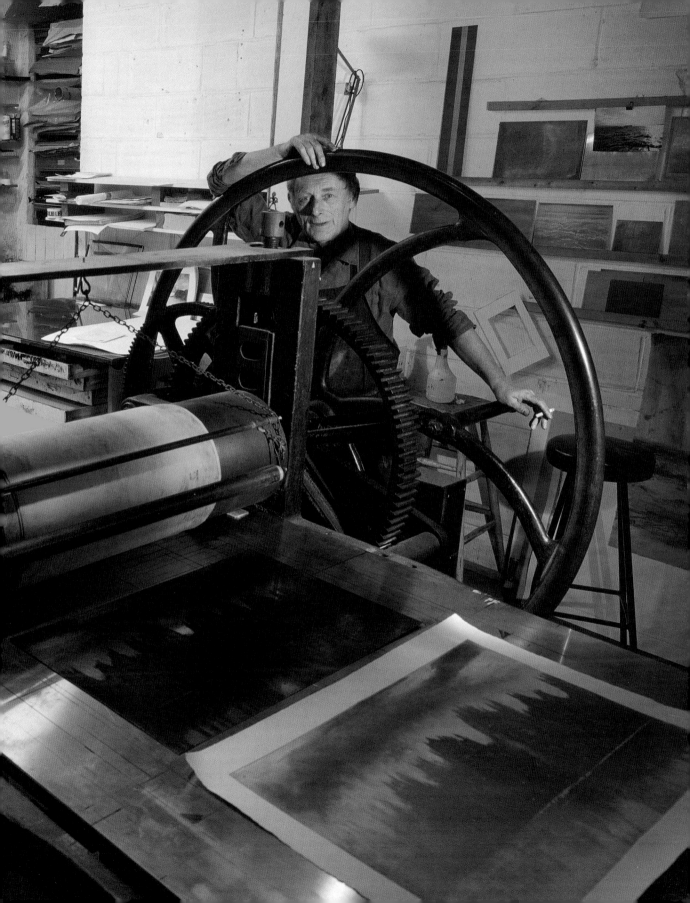

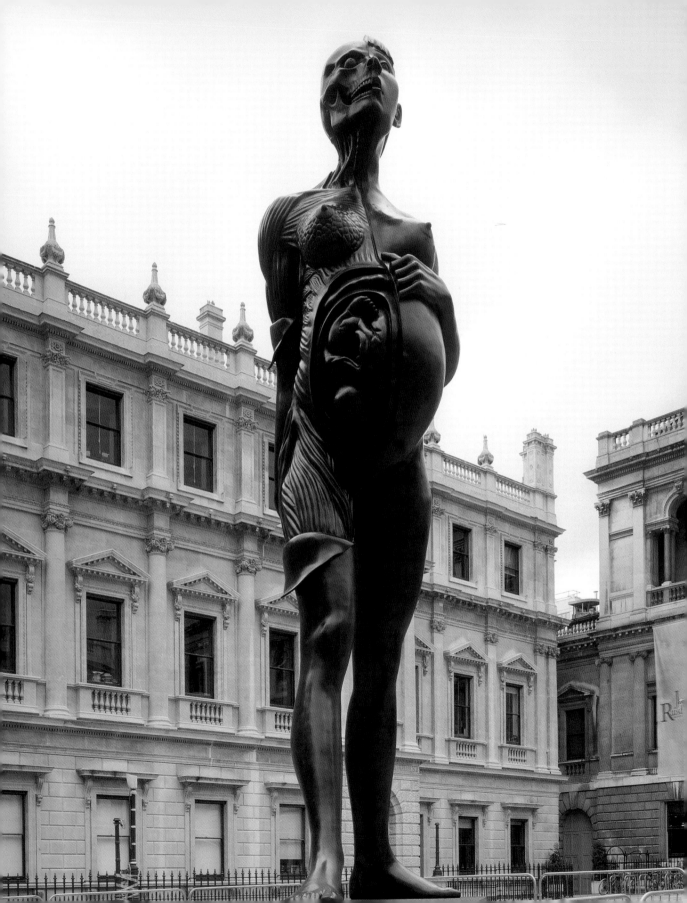

Contents

Sponsor's Foreword

Insight Investment – part of the HBOS Group – is one of the UK's largest asset managers: managing money for private investors, pension funds, insurance groups and other institutions. This year's Summer Exhibition is exciting for us as it marks the first year of our sponsorship and heralds what, we hope, will become an enduring partnership. We are delighted to be supporting the Royal Academy and we very much hope our customers, business partners and colleagues will find inspiration in the creativity and diversity on display at this unique event.

Our purpose at Insight Investment is to make more people better off. This extends beyond the strict financial definition to ensuring that we contribute to the enrichment of people's lives in a financial, social, environmental or cultural sense. Underpinning this goal is inspired thinking. This defines both what we do and how we do it. It governs our approach to creating tailored investment solutions to meet our customers' needs. For us, inspired thinking is about breaking new ground, being brave, taking measured risks, challenging convention, thinking boldly, differently and brilliantly in everything we do. Inspired thinking is what you will find in abundance at this year's Summer Exhibition. These values have brought us into partnership with the Royal Academy: allowing us to combine the best from the business and the art worlds. We are also delighted to give visitors to the Summer Exhibition the opportunity to decide who should be awarded the 'Insight Image of the Year' award. For the first time in the show's rich and dynamic history, visitors will be able to vote for their favourite picture from a shortlist selected by a panel of judges. A prize of £10,000 will be awarded to the winning artist at the end of the show.

We hope you will enjoy the Summer Exhibition as much as we have enjoyed working with the Royal Academy in bringing it to you.

Douglas Ferrans
Chief Executive Officer

Introduction

Tom Phillips

The Summer Exhibition is a *salon*, the most successful of all those that once graced the season of Europe's capital cities. It is in effect the only one that has robustly survived into the twenty-first century. The key to its continuing health – and wealth, since it currently achieves sales of over two million pounds – is that it is selected, curated and hung by artists.

It offers the public an opportunity, now unique, of seeing virtually the whole map of present artistic endeavour. Those who want their choices limited to what is fashionable in the hothouse of the so-called 'art world' must restrict themselves to the cloned museums of contemporary art. Here at the Royal Academy each year the ample dialogue of art is available in all its intriguing complexity. While artists approved by the consensual cabal of dealers, critics and museum curators are indeed here in force, they happen to share the Academy's space with those less in vogue, the quietists, the explorers of traditional themes and verities, and the occupants of the more rarefied corners of creativity. Among the exhibitors are also those who have temporarily slipped from celebrity. They will no doubt be taken up again but meanwhile find haven together with those on whom the fickle spotlight has yet to fall.

Yes, there are those as well who, in ungrudging obscurity, still tend the most overgrown paths in art. But who is to guarantee

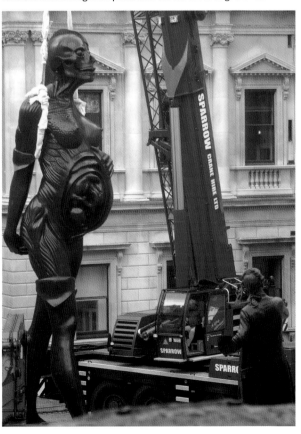

Installation of Damien Hirst's
The Virgin Mother

that a genre such as still-life may not yet preoccupy a genius of the future? Such options are thus kept open. Indeed, as I write this, the best-known British artist of my generation, David Hockney RA (not showing this year), is out in the fields of East Yorkshire, as he has been through the whole of the recent harsh winter, reinventing the language of large-scale plein-airist landscape.

As the stylistic spread is wide so is that of age. One large abstract canvas, *Sex and the City*, sailed through the selection and turned out to be by a first-year student of the Royal Academy Schools, Ann-Caroline Breig, who now hangs high (but not too high) in Gallery III with established abstractionists fifty years her senior. Two members, Frederick Gore and the architect Leonard Manasseh, are seen to be working in their nineties with their familiar enthusiasm.

It is easy to forget that at its foundation the Royal Academy was an international body whose members included the Chinese sculptor Tan Chitqua, the Swiss painter Angelica Kauffman and the American Benjamin West, who became its second President. This tradition is upheld by the election of distinguished colleagues as Honorary Academicians who exhibit periodically. This year Tadao Ando, Mimmo Paladino, Georg Baselitz and Anselm Kiefer all contribute substantial works.

Another traditional element of the exhibition is to honour any members who have died in the last year. These tributes usually take the form of a group of their works being prominently displayed. Two artists, both exceptional in the public eye, who played a generous part in the life of the Academy, were lost to us this year and it seemed fitting to celebrate each of them with a dedicated room.

Eduardo Paolozzi was a larger-than-life figure with the most massive hands I have ever seen; a kindly giant who was always ready to help young artists, as I know to my benefit. It was over forty years ago that I bumped into him on the train to Ipswich and introduced myself. Seeing my sketchbook he asked to look through it. He examined my tentative drawings with more care than they deserved, understanding immediately what I was trying (and at that time failing) to do. The warmth of his encouragement is with me still. My last memory of Eduardo was after his second stroke when I helped him round an exhibition at the RA. He could not speak, yet his eyes showed which sculptures excited him. Spotting a Brancusi he lurched perilously towards it, his strength still prodigious, while I struggled to keep control of the guiding wheels of his walking frame. He loved the Academy and even before he became chairman of its Library Committee was as prodigal with his time as with his gifts to its collection.

Patrick Caulfield was a much more private individual. Shyly convivial, he was best met in the company of his artist wife Janet Nathan (also showing this year) and close friends. It is difficult to guess, when electing a member, whether he or she will choose to take an active part in the life of the Academy. Patrick will be remembered as often holding court in the Members' Room, which he was eventually to redesign and refurnish in an exotically revisionist style.

It was a distinctly English vein of Shandean anarchy that gave his paintings and prints the freedom that spiced their elegant perfectionism. He and Eduardo, as internationally established artists, demonstrated in their respective reticence and prodigality, severity and ebullience, the breadth of aesthetic debate in British art. No two rooms could offer a greater contrast. Patrick's must be the most serene and beautiful room of pictures currently on view in London and Eduardo's surely must offer the greatest concentration of energy and invention.

The bulk of the exhibition is of course provided by the contributions of the members and those who submit their work from outside, the latter accounting for about 60% of what is on show. The initial selection by the committee takes the form of a rapid weeding out to leave a store of work that will be given more considered scrutiny in the process of hanging. This occupies a week during which the great galleries start as a trading floor with works squirrelled away or offered to (and occasionally poached from) fellow hangers until the content of each room is roughly established. Hanging is not easy: it is as problematic to arrange a dozen or so huge pictures or a large group of smaller works as it is to make sense of a forest of sculpture or to articulate a maze of architectural models and drawings. It is at this point that many works have, often with regret, to be put aside in the category of 'accepted but not hung' that brings only modified satisfaction to those who have sent them in.

As a co-opted hanger I had to some extent a choice of rooms, and elected to work on Gallery X. The principal problem with this final gallery is that it greets an already exhausted and visually bombarded visitor. Gallery X has tended to become the graveyard of the galleries, the last refuge of the unplaceable, to be sleepwalked by those with an eye to the shop or a yearning for a seat in the café. It should, therefore, like the end of a long banquet, try to offer some extra delights and administer the bracing stimulation equivalent to a cup of coffee: as it happens, this year it manages at least to serve up, in the work of Sarah Lucas, a cigarette.

My gathering of work started in the time-honoured manner with a piece that interested many but was impossible to place, the lighting fixture by the notorious Turner Prizewinner Martin Creed which, like his Tate installation, goes on and off and on again. This seemed to me to hint at a perfect end to the show, especially if accompanied (and thereby given some extra meaning)

by a last reminder of the contribution to the Academy of Caulfield and Paolozzi. Another recent Turner Prizewinner, Grayson Perry, occupies the vista from the previous gallery.

Having also appropriated two maquettes by Damien Hirst which echo the gigantic courtyard sculpture which acts as the bronze overture to any visit, I set about rounding up other artists who had featured in the Academy's 1997 'Sensation' exhibition to make a small reunion. This quest was well rewarded, firstly by the beautiful painting by Marcus Harvey whose *Myra* was for me the outstanding (and for the press and the public the most provocative) work in that event. This was followed by Tracey Emin with a nervously delicate study in her characteristic manner, and in turn an enigmatic fur-covered ovoid from Gavin Turk as well as a savoury little painting of elves by Jake and Dinos Chapman whose title, *Two little pixies happy as hell on reception of the news that Jake & Dinos are finally receiving their RA, as promised. Thank you very much for your kind attention*, is as long as that of Sarah Lucas's cigarette piece, *Gnorman*, is short. Thus eight of the artists who participated in 'Sensation' (including Gary Hume RA) make a welcome return to the scene of their still controversial triumph.

The most rewarding moment in the process of hanging, however, is to find an artist of whom one has never heard. Oliver Clegg's work shone out whenever I encountered his two haunting images. He seems to have the visual equivalent of perfect pitch which makes his submissions stand up to comparison with those of veteran exhibitors like Victor Newsome, whose inimitable drawings reach a new height in his interpretation of the scene at Golgotha.

Each gallery necessarily contains the work of members and Gallery X is no exception. I wanted to make a substantial feature of the most recently elected member, Richard Wilson RA, as the centrepiece of the principal wall. As well as my own work, and two sculptures by Alison Wilding, gladly appropriated from her own gallery to give their refinement better focus, there are two paintings by one of the most senior members, Flavia Irwin RA (wife of the late past president Sir Roger de Grey), whose almost whispered canvases have been a staple of the summer show for over a generation. Honorary members are represented by Ed Ruscha and Mimmo Paladino.

I had opted in addition to be the clearing house for photo-graphy in the hope of promoting a once despised category of art that the Royal Academy has yet fully and belatedly to embrace and one to which it wishes to pay attention. This, albeit modest, group of photographs has shifted and changed more than any other and it was only a late discovery in a far stack that finally, in the seventh hanging in that area, made it coherent. Two works involving photography mark the exit from the exhibition as a whole: an innocent and optimistic field of flowers by Michael Autumn and John Keane's more troubled field of faces act as final emblems of

war and peace which echo the announced theme of this year's exhibition, 'From Life'.

There used to be a tradition at the great *salons* of producing critical commentaries, often by distinguished writers such as Diderot, Baudelaire and Ruskin, that served as room-by-room guides and included withering judgements as well as praise. Here I have dwelt on the only gallery I know intimately, some of whose works I have stared at for over a week before eventually placing them here or there, and could almost draw from memory. Naturally I did pass through all the rooms frequently in search of something to pilfer, or to find asylum for a work that I found alien to what had become my project. In doing so I saw my colleagues in similar throes of indecision or revision as pictures migrated from wall to happier wall or sculptures loitered awaiting patriation. Like me, each of my fellow Academicians had become, as the disposition of their galleries started to resolve itself, more and more protective of his or her hoard and its placement. The emergent personality of their rooms, with key paintings hung as custom dictates 'on the line' (i.e. more or less at eye level), was fascinating to observe.

In each case there had arrived a satisfying moment as when a puzzle tumbles towards a solution, a point at which such stubbornness takes over. No stranger now, each thinks, will infiltrate, invade or alter this arrangement, where even the art objects I have not entirely taken to at least look their best.

One's ultimate inflexibility is revealed when, as is the case in every Summer Exhibition, one is faced with the two or three remaining intractable objects which must perforce be accommodated, but can find no welcome. For a week now they have been looking shifty in this or that corner. Even these, however, find some lately developed gap in which to take refuge.

The final moment in the long journey of days, like an extended Test Match with its convivial and argumentative breaks for lunch and tea, is when the exhibition as a whole is sanctioned by the Academy's Council. As they and the hangers process through the galleries with the President in the lead (and this year with a TV crew in their wake) all seems orderly, like a raucous playground of children suddenly grown quiet. Everything seems to be in its obvious and inevitable place as if there never had been problem or panic. Indeed, why, since it was self-evidently so straightforward a job, had it taken so long and caused so much furrowing of brows?

With the debris of crates and packing cleared away we ourselves were struck by the well-defined character of each of the rooms. Some of course are Summer Exhibition faithfuls, like the jackdaw's nest of the Small Weston Room (which confusingly to the ear used to be known as the Small South Room). The galleries hung by Ken Howard and Ben Levene (Galleries II

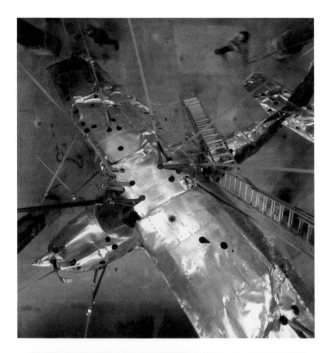

Richard Wilson RA
Butterfly (detail)

Marcus Harvey
Toilet Roll

and V respectively) provide the reassurance that there is still a thriving heart to the conservative traditions of British art. Then there are innovative surprises like the sculpture room (the Lecture Room) that Alison Wilding and David Mach have transformed into an aesthetic adventure playground, and the fact that all the obvious 'major works' are not crowded into the hallowed Gallery III but command attention by their sudden appearance at strategic and unexpected intervals.

Even we who were given the task can no longer believe how a week ago it seemed scarcely possible to make a coherent show from a chaos we can now hardly remember. A great factor in that final calm had been those experts with ladders and hammers and trolleys and lights who had throughout been so efficient and genially indulgent to innumerable changes of mind and who were able so often, with a diplomatic cough or muted suggestion, to guide as much as assist. But one person above all (yet behaving as above no-one) who carried not just a single gallery but the whole show in her head from the beginning, and who kept all its attendant logistical and administrative nightmares to herself while dealing with everyone's needs and problems, was Edith Devaney, an ever-present siren of smiling anxiety who masterminded the whole affair.

An academy cannot by definition be entirely avant-garde (else what would the 'garde' be 'avant'?). Newspaper pundits who say that the annual exhibition is always the same need only look at the *Royal Academy Illustrated* of the 1950s or 1960s, or even the 1970s, to appreciate how it has evolved (after its years in the doldrums) and now represents a greater variety of art's constituencies than ever before. Those who like to speak of a Golden Age of the Royal Academy when the likes of Constable and Turner set the standard would be surprised to recognise only a few familiar names in the lists of nineteenth-century exhibitors, together with a huge array of artists long lost to oblivion. Who knows indeed what stars may be seen to have risen or fallen by those who, via whatever yet unborn technology, glance in a hundred years' time at this book or peruse the catalogue? Fashion is fun and novelty diverting but history will turn out to have had its own ideas.

The Summer Exhibition at the Royal Academy is an event in which anyone can find pleasure, even though the laziest critics still love to hate it. For those who collect or suddenly feel they are on the verge of acquiring some art of their own it is the best of all shops with the most lavish of stocks and the widest price range. One thing I can guarantee is that it contains at least half a dozen masterpieces. If you care about art it will reward a few hours of enjoyably taxing absorption – for it is your judgement as well as our work that is on the line.

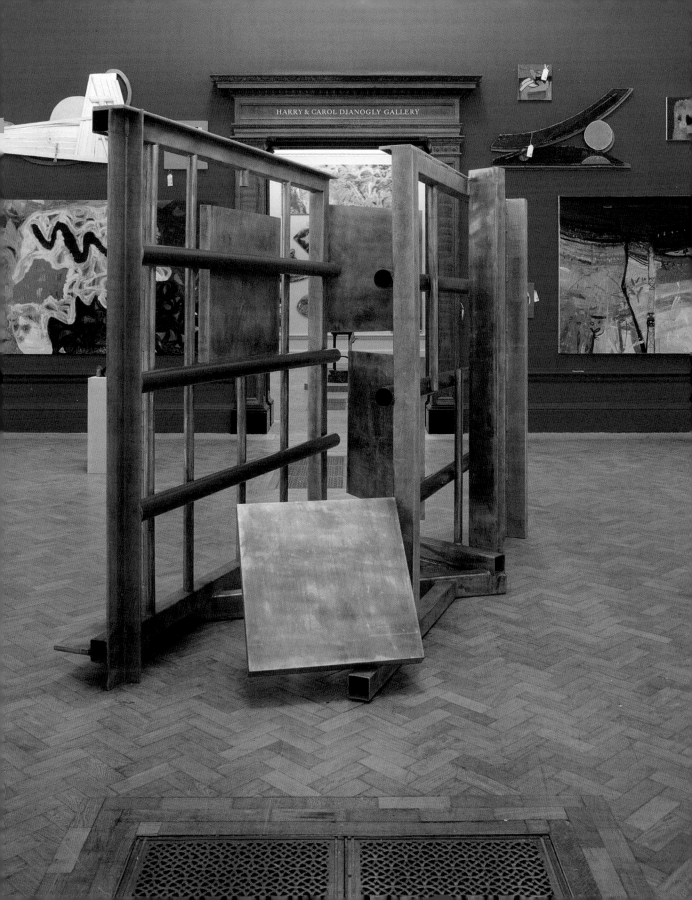

Albert Irvin RA
Beckett
Acrylic
212 × 306 cm

Paul Tonkin
Vagabond
Acrylic
180 × 284 cm

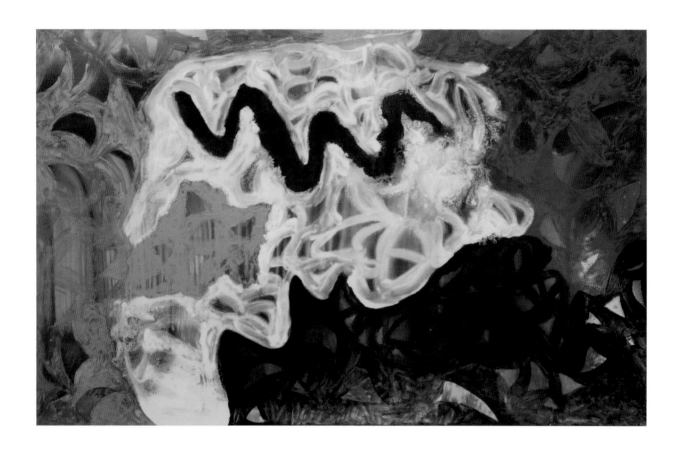

Lisa Milroy RA
Painting Fast Painting Slow
Mixed media
126 × 680 cm

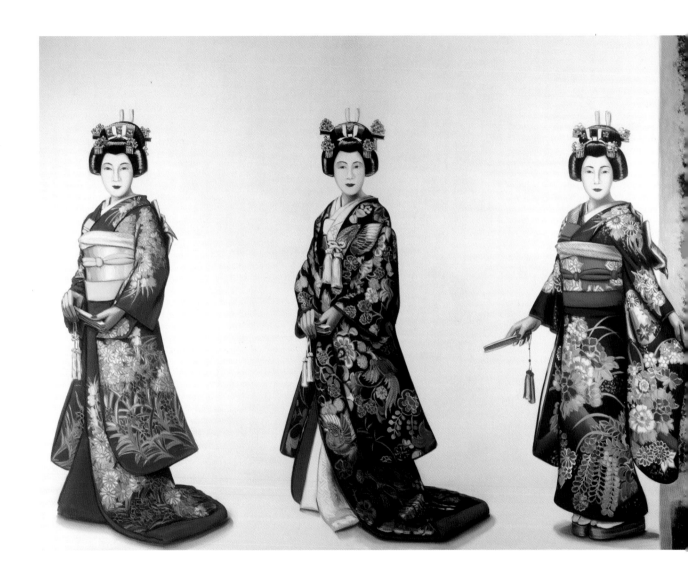

Prof Maurice Cockrill RA
Study for Pathology
Oil
61 × 51 cm

Kenneth Draper RA
Veiled Light/Pregonda
Pastel
43 × 53 cm

Prof John Hoyland RA
Love and Grief 5.4.006
Acrylic
153 × 126 cm

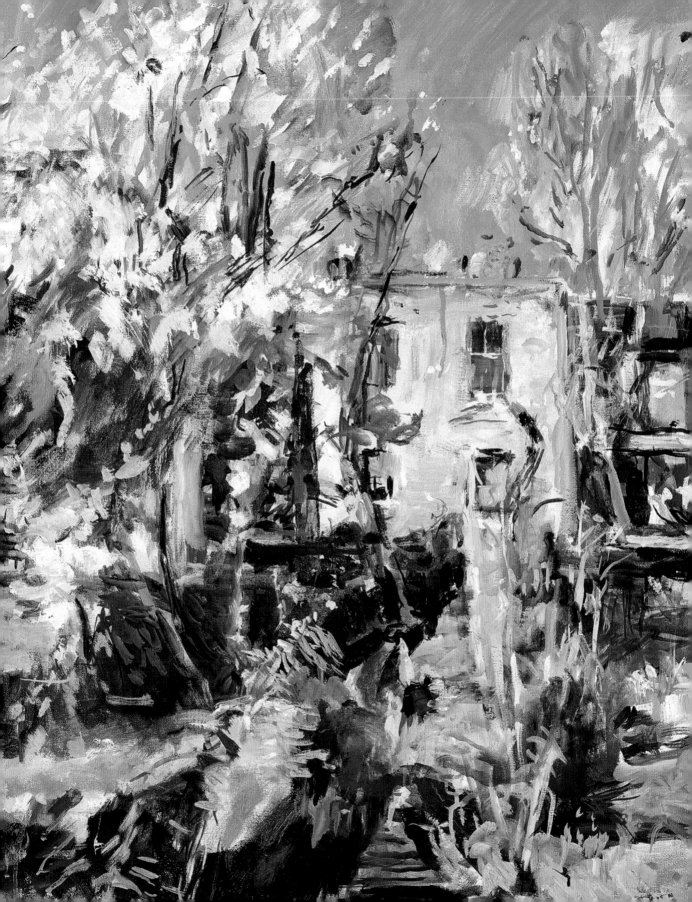

Ben Levene RA
Trailing Fuchsia 'Harry Gray'
on Mason Ironstone Plate
Oil
80 × 96 cm

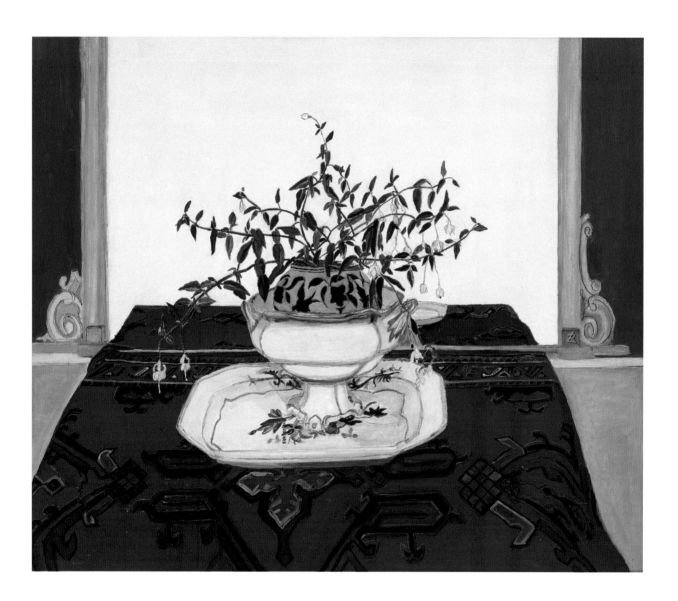

Anthony Eyton RA
Cherry Blossom
Oil
90 × 100 cm

Olwyn Bowey RA
Ornamental Gourds
Oil
68 × 74 cm

Bernard Dunstan RA
Campo S. Apostoli
Oil
27 × 23 cm

James Butler RA
The Beautiful Dancer
Bronze
H 62 cm

Leonard Rosoman OBE RA
Artists in a Studio
Acrylic
96 × 82 cm

Prof Ken Howard RA
Raineffect. London
Oil
150 × 181 cm

Frederick Cuming RA
Cutty Sark
Oil
95 × 100 cm

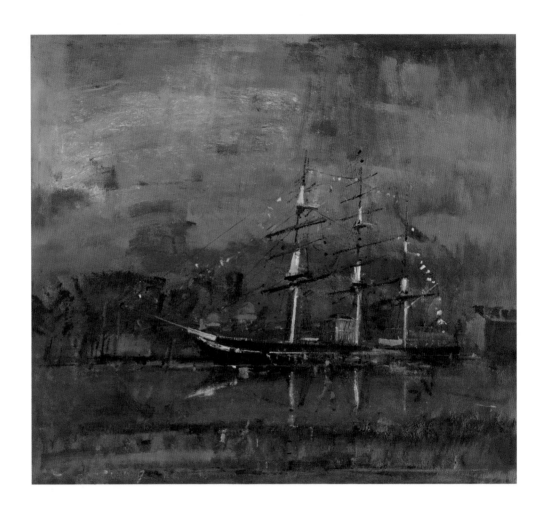

Jeffery Camp RA
James at the Seaside
Oil
44 × 69 cm

Anthony Green RA
The Path, III
Oil
86 × 120 cm

David Tindle RA
Jacket and Screen
Egg tempera
80 × 57 cm

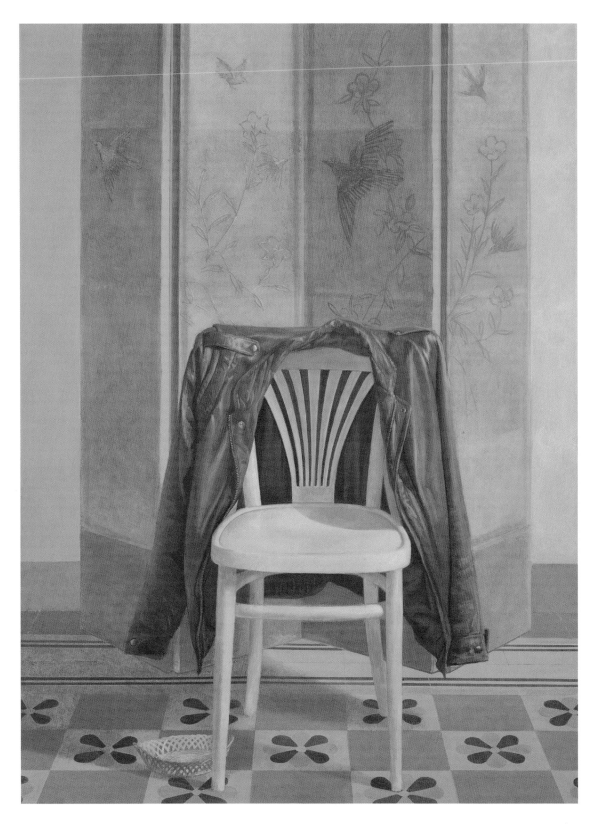

LARGE
WESTON
ROOM

Barbara Rae CBE RA
Valentia Shore
Etching
60 × 56 cm

Craigie Aitchison CBE RA
Cypress Tree and Dog
Screenprint
27 × 20 cm

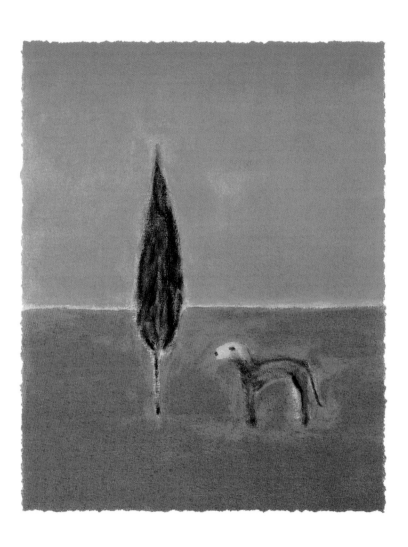

Bill Jacklin RA
New York Skaters VIII
Monoprint
69 × 54 cm

Prof Chris Orr RA
My Chinese Opera
Lithograph
88 × 64 cm

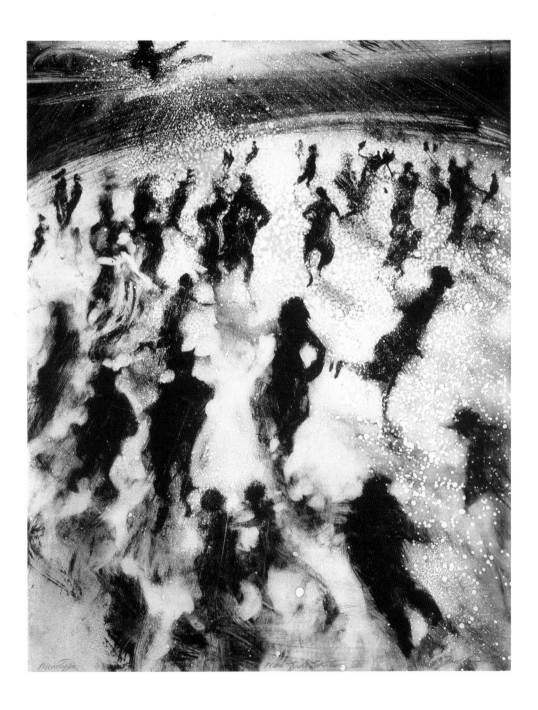

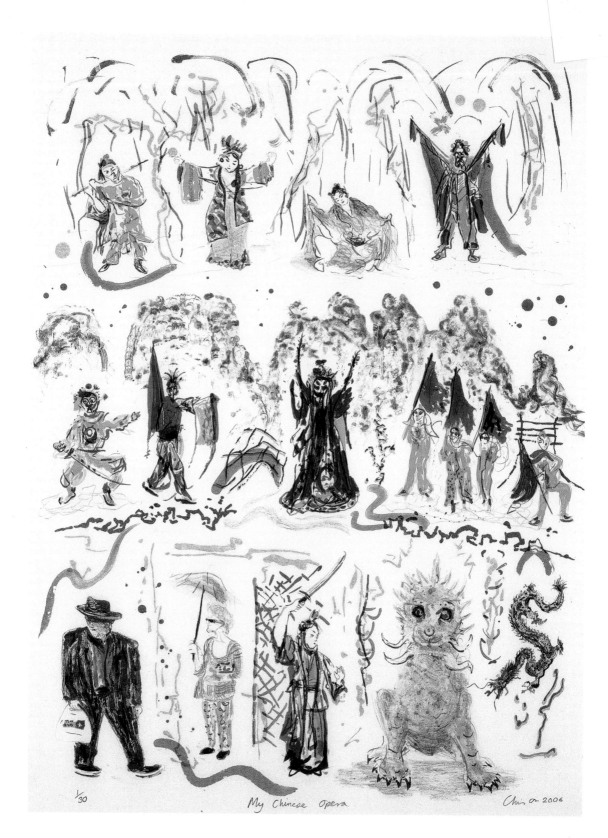

1/30　　　　　　　My Chinese Opera　　　　　Chis on 2006

Judith Lockie
Setting Out
Etching
9 × 16 cm

Prof Christopher Le Brun RA
Rider
Etching
20 × 17 cm

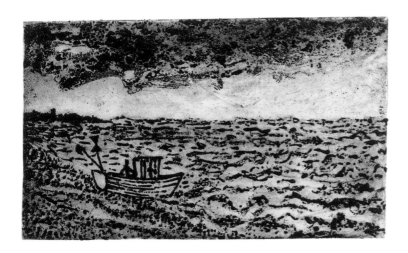

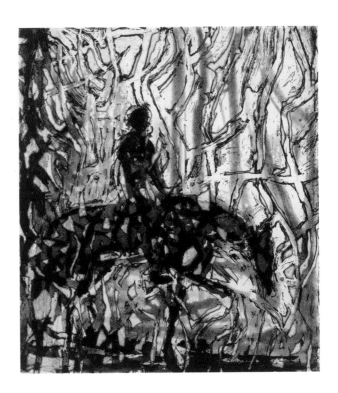

Jim Dine
Black and White Flowers III
Etching
78 × 64 cm

Julian Meredith
Pod
Woodcut
105 × 200 cm

John Gledhill
Ships in the Night
Linocut
34 × 30 cm

Helen Fay
Florence
Etching
64 × 64 cm

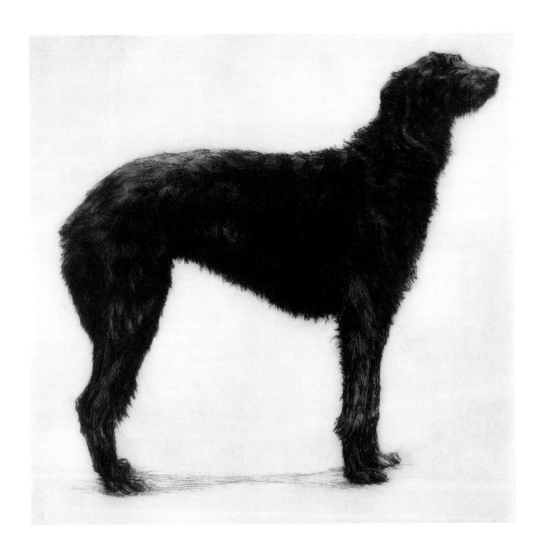

Jennifer Dickson RA
The Gods: One (Apollo)
Giclée print
48 × 28 cm

Richard Hamilton
Simon Dedalus
Mezzotint
12 × 11 cm

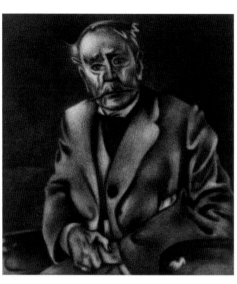

Eileen Cooper RA
Country Life
Lithograph
38 × 56 cm

Jessica Holmes
Slate Twice
Digital print
50 × 70 cm

Prof Bryan Kneale RA
Crucible
Bronze and copper
H 55 cm

Gillian Westgate
Bishopsgate Cowboy
Linocut
22 × 28 cm

John Carter
Meander Theme: Two Parts 2005
Aquatint etching
35 × 27 cm

Nana Shiomi
Mirror Room
Woodcut
45 × 120 cm

Katherine Lubar
Crosses
Giclée print
25 × 25 cm

Tom Phillips CBE RA
After Turner
Lithograph
20 × 26 cm

Peter Freeth RA
Bodies
Aquatint
13 × 17 cm

Ivor Abrahams RA
Prop
Monotype
43 × 63 cm

Daniel Wallis
Orange Tom
Print
17 × 21 cm

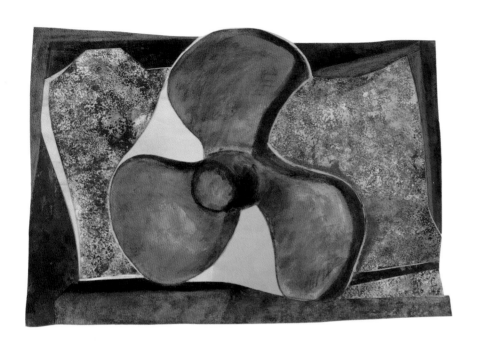

Simon Lawson
Three Pears
Lithograph
61 × 81 cm

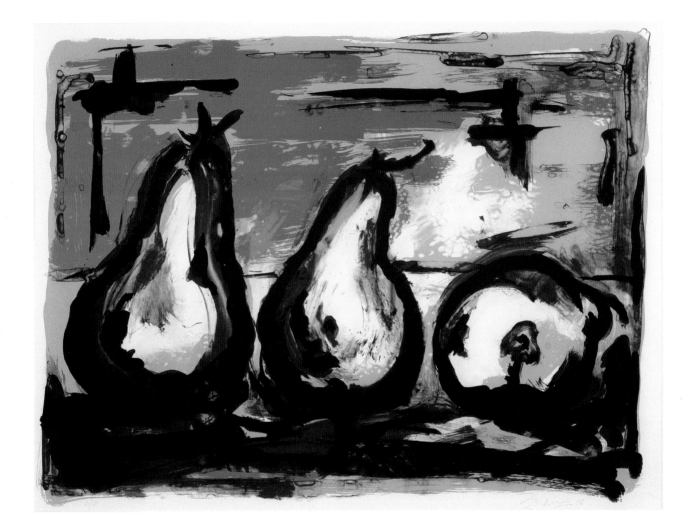

Prof Norman Ackroyd RA
High Island – Connemara
Etching
17 × 25 cm

SMALL WESTON ROOM

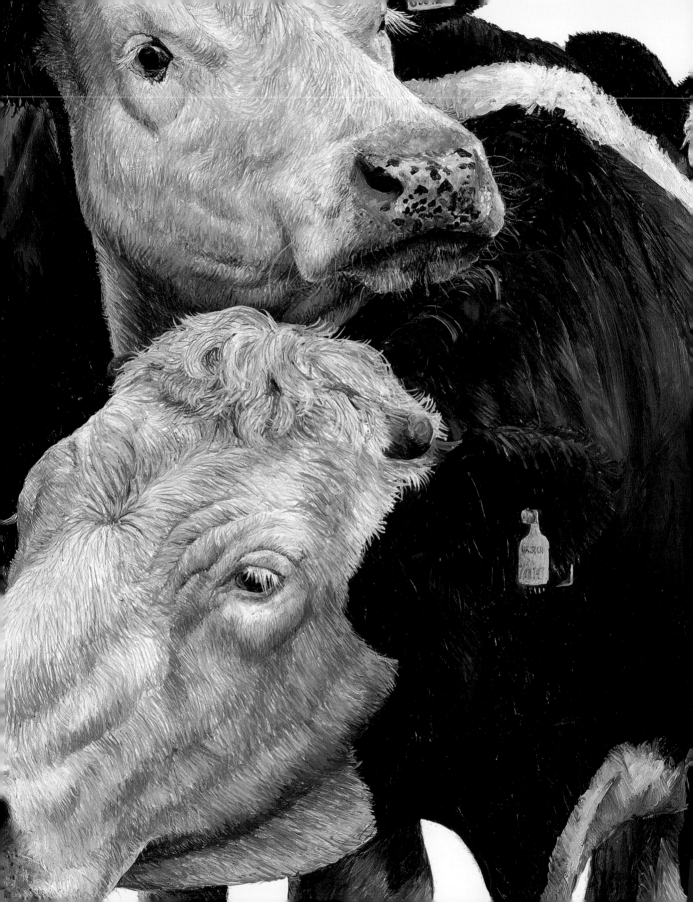

Martin Leman
The Great Umbrella Topiary
Oil
52 × 48 cm

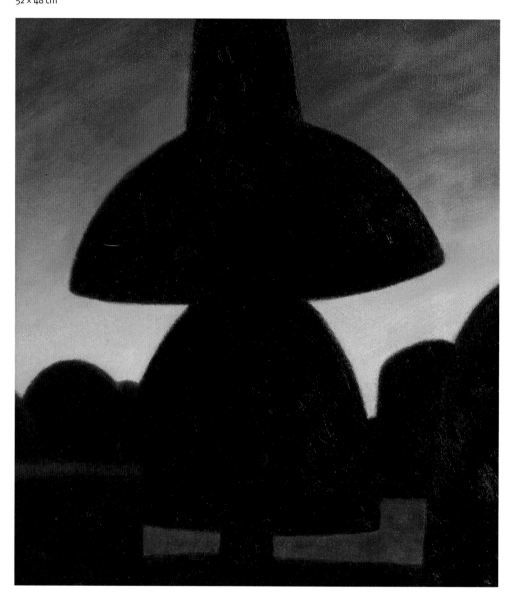

Julian Gordon Mitchell
For the Bachelor (I)
Oil
25 × 20 cm

Naomi Alexander
Arab House – Israel
Oil
20 × 60 cm

Matthew Baker
Electric Cooker (Home from Home)
Oil
30 × 30 cm

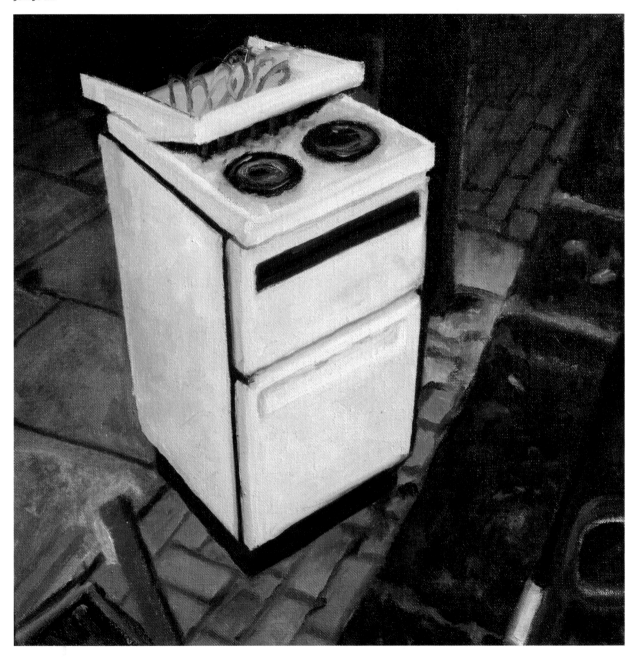

Ho Yun Milner
Somewhere Else 3
Egg tempera
33 × 33 cm

Diana Armfield RA
Dawn Flush on the Snow, Llwynhir
Oil
25 × 25 cm

Martin Yeoman
French Dancer
Pastel over monotype
40 × 30 cm

Edmund Fairfax-Lucy
Painting in Grey No. 2
Oil
39 × 30 cm

Frederick Dubery
Fish Plate
Oil
43 × 58 cm

Sally McGill
Seeds of Life III
Oil
36 × 36 cm

Jack Kettlewell
Health and Safety
Acrylic
22 × 22 cm

Robert Dukes
Farrow and Ball Sample Pots
Oil
12 × 25 cm

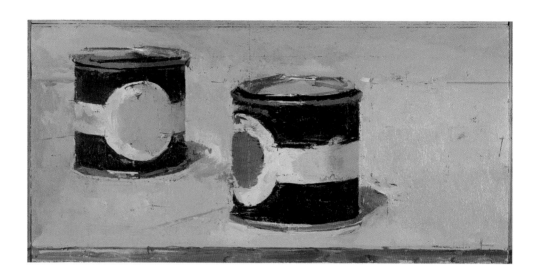

Richard Combes
Apartment Security
Oil
30 × 35 cm

Ingrid Wilkins
Figure into Landscàpe I
Oil
15 × 15 cm

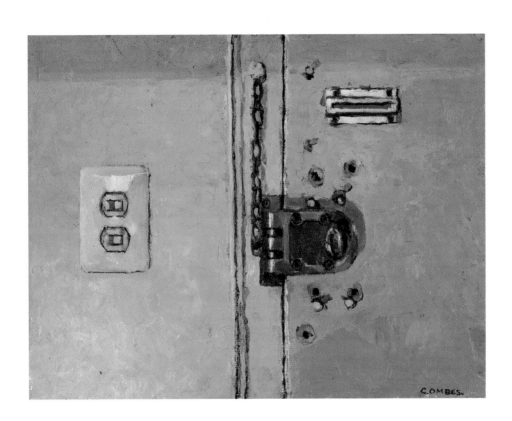

Katie Jones
A Friendly Jostle
Oil
30 × 30 cm

Georg Baselitz HON RA
Das Unsichtbare Klavier
Oil
355 × 305 cm

Ian McKeever RA
Four Quartets 7
Gouache
101 × 51 cm

Flavia Irwin RA
Shadow Cast I
Acrylic
92 × 61 cm

Sandra Blow RA
Blue and White Collage
Mixed media
270 × 270 cm

Donald Hamilton Fraser RA
Flying Kites
Oil
120 × 90 cm

Antoni Malinowski
Dark Lapis
Acrylic
244 × 167 cm

Stephen Chambers RA
The Island (with Constant Chaos)
Oil
160 × 200 cm

Prof Stephen Farthing RA
Dumanoir's Failure
Oil
207 × 303 cm

Ann-Caroline Breig
Sex and the City
Mixed media
213 × 265 cm

Humphrey Ocean RA
Untitled (Train)
Oil
105 × 125 cm

Chantal Joffe
Blond Girl – Black Dress
Oil
244 × 181 cm

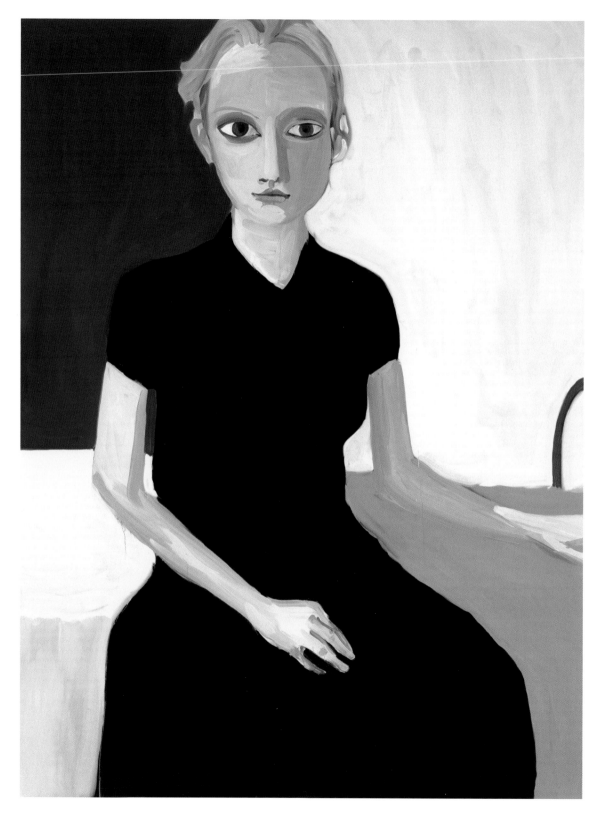

Anselm Kiefer HON RA
Die Nornen
Mixed media
280 × 380 cm

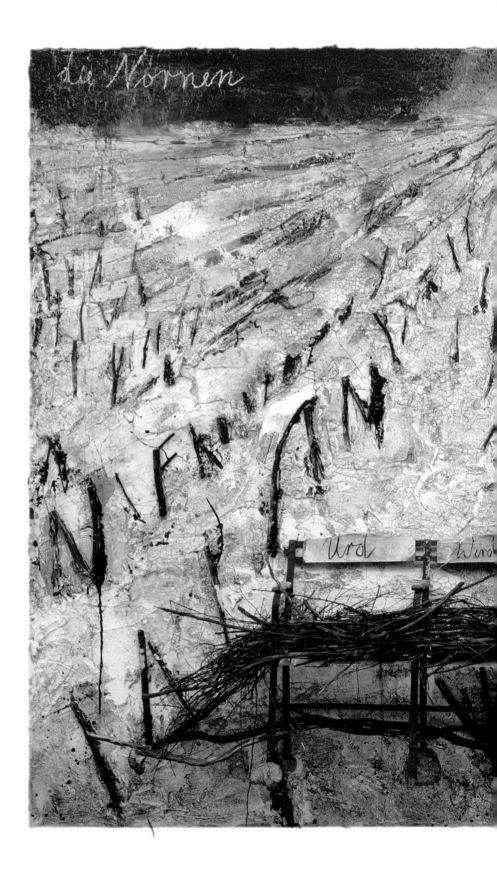

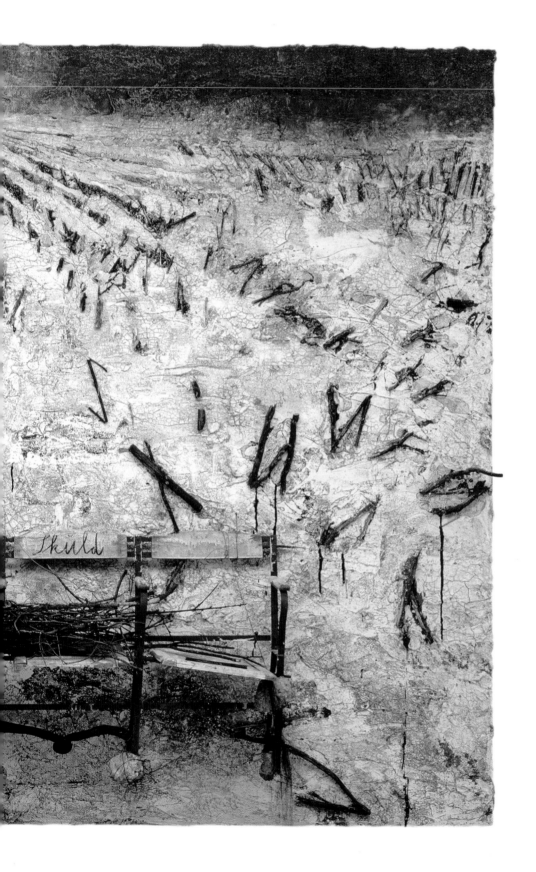

Prof Paul Huxley RA
Lu (Green)
Acrylic
126 × 126 cm

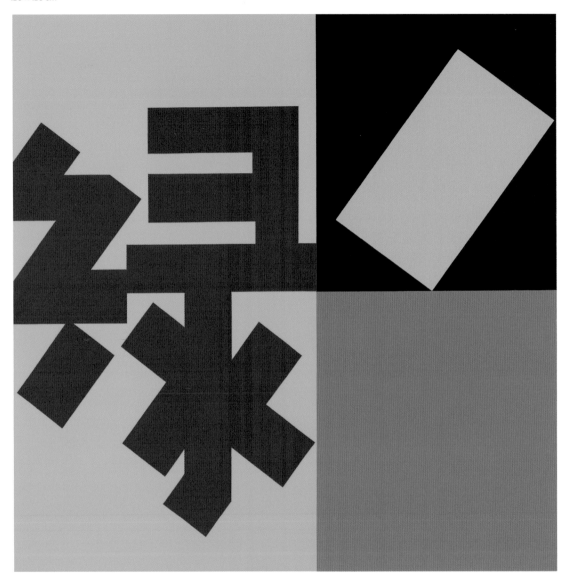

Richard Smith
Untitled 2001
Oil
137 × 78 cm

Jennifer Durrant RA
From a Series Last Conversations (21) 2004
Mixed media
16 × 21 cm

Leonard McComb RA
Portrait of Simon, Karen Day, and Family
Oil
154 × 195 cm

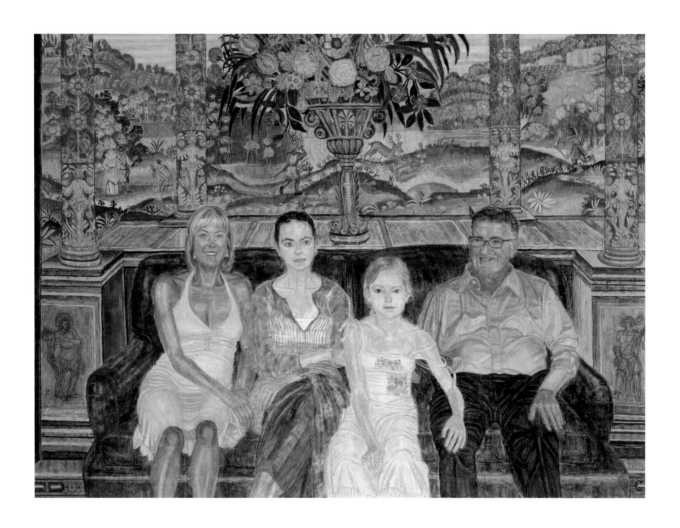

Frederick Gore CBE RA
Primrose Hill in May
Oil
69 × 104 cm

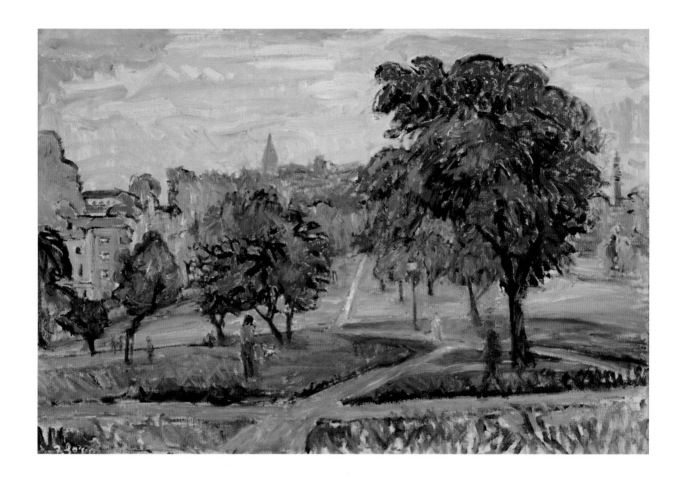

Gillian Ayres OBE RA
Maritsa
Oil
191 × 305 cm

The Late Patrick Caulfield CBE RA
Happy Hour
Acrylic
193 × 193 cm

The Late Patrick Caulfield CBE RA
Unfinished Painting
Acrylic
75 × 89 cm

The Late Patrick Caulfield CBE RA
Villa Plage
Oil
336 × 152 cm

The Late Patrick Caulfield CBE RA
Document
Acrylic
106 × 91 cm

The Late Patrick Caulfield CBE RA
Bishops
Acrylic
213 × 198 cm

The Late Patrick Caulfield CBE RA
Holiday Home
Acrylic
213 × 183 cm

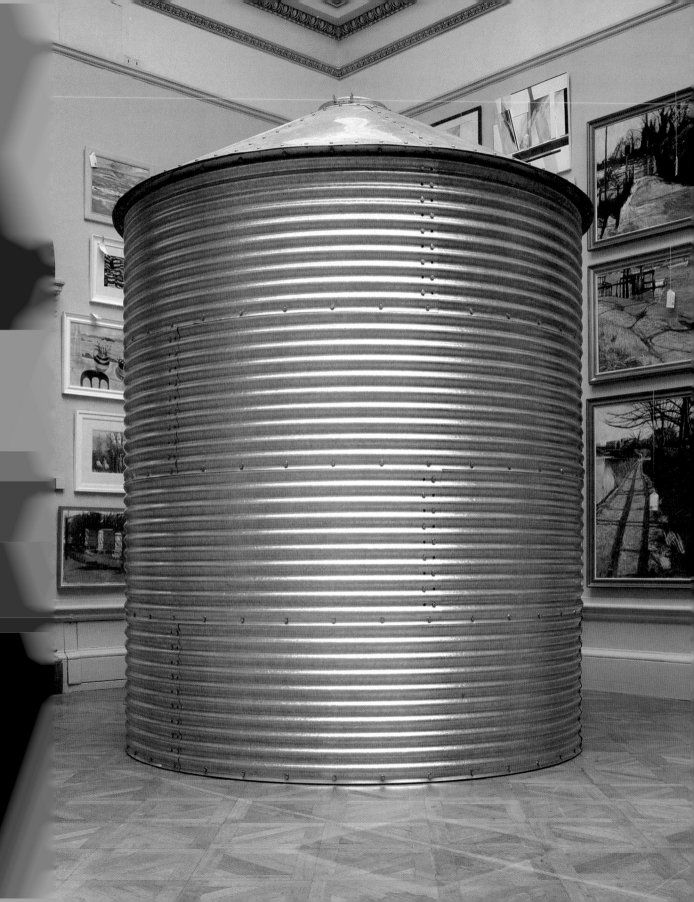

Adrian Berg RA
The Botanic Garden Madeira, 25 October
Oil
66 × 97 cm

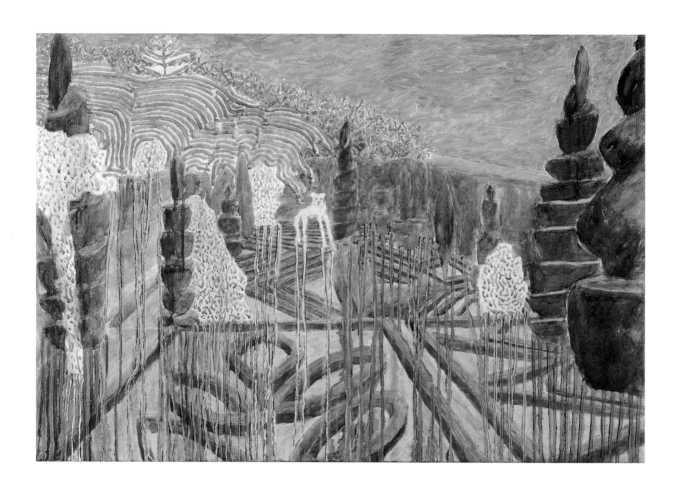

Jean Cooke RA
OK Weepers
Oil
66 × 60 cm

Dame Elizabeth Blackadder DBE RA
Still-life, Lilies, Gerberas and Indian Miniature
Oil
100 × 100 cm

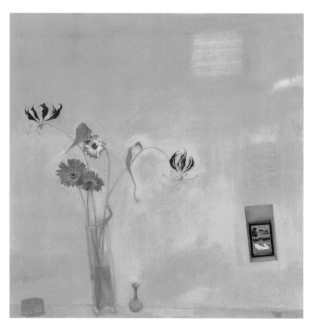

Brian Plummer
Mallerstane Edge
Pencil
59 × 81 cm

Lorna Brown
Window
Mixed media
70 × 71 cm

Mary Fedden OBE RA
Irish Lilies
Oil
89 × 69 cm

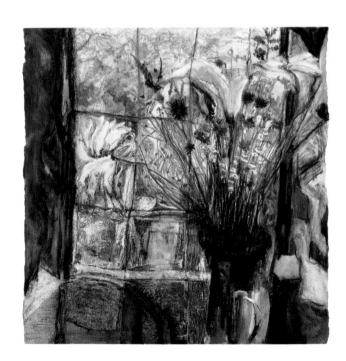

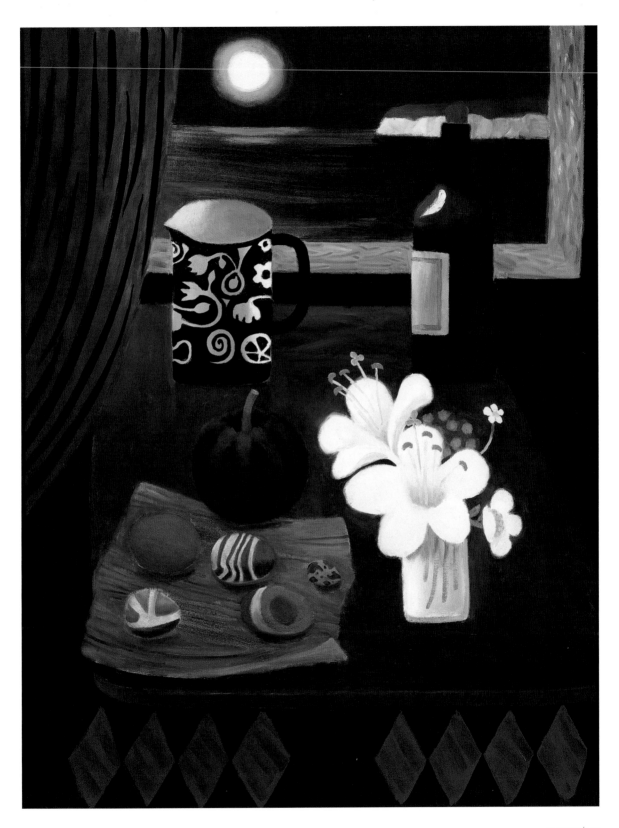

John Wragg RA
Dreaming of Black Birds
Acrylic
126 × 84 cm

George Underwood
Moondog
Oil
67 × 57 cm

Mick Rooney RA
Watching Fireworks (Spain)
Oil
165 × 111 cm

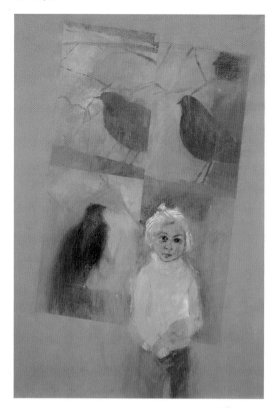

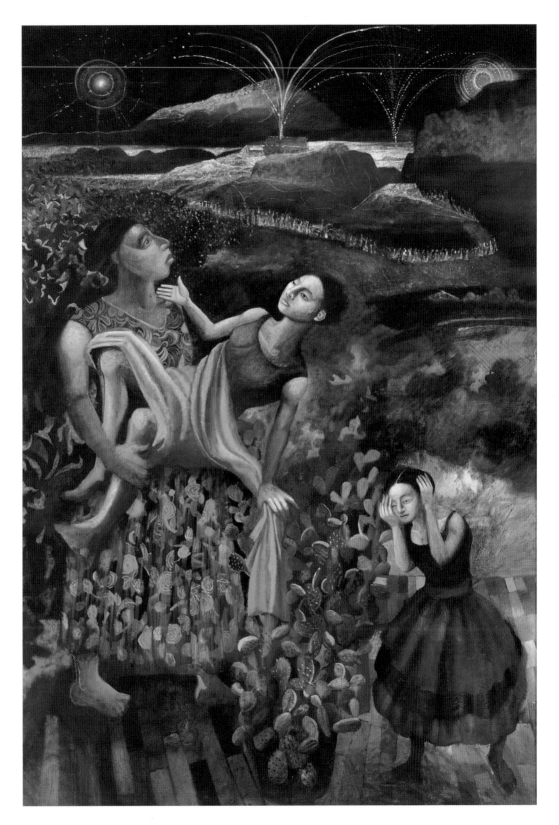

Jesse Leroy Smith
Swimmer
Oil
124 × 106 cm

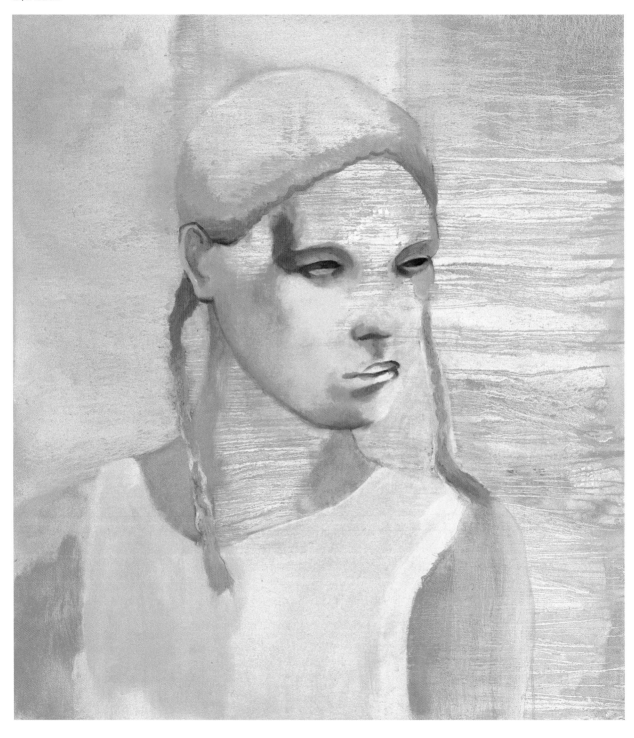

Charlotte Steel
Self–portrait
Oil
60 × 40 cm

Caroline Styles
Dried Flowers
Oil
87 × 61 cm

Philip Sutton RA
Good Morning Wizard!
Oil
68 × 68 cm

John Bellany CBE RA
Pulpit Vase and Orchids
Oil
120 × 90 cm

George Rowlett
*Dolphin and Pontoon by the
Ballast Yard with Canary Wharf*
Oil
72 × 133 cm

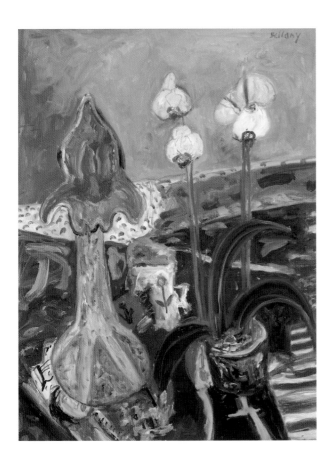

Julie Held
Heat
Oil
120 × 90 cm

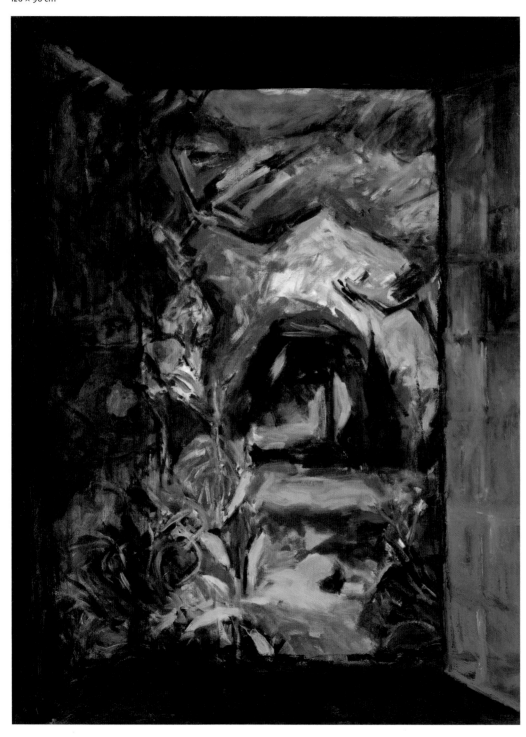

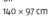

William Bowyer RA
The Lone Cyclist
Oil
140 × 97 cm

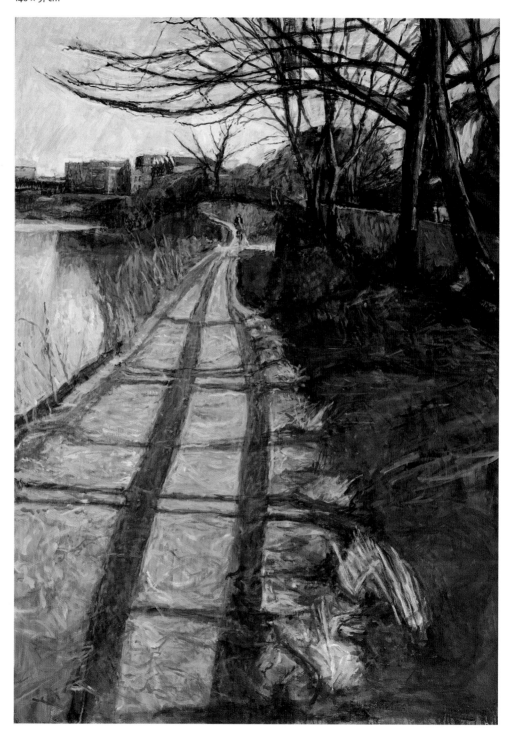

Lord Rogers of Riverside RA (Richard Rogers Partnership)
Naples Airport Underground Station
Pen on tracing paper
30 × 88 cm

CJ Lim
Battersea Dogs Home (detail)
Mixed media
60 × 80 cm

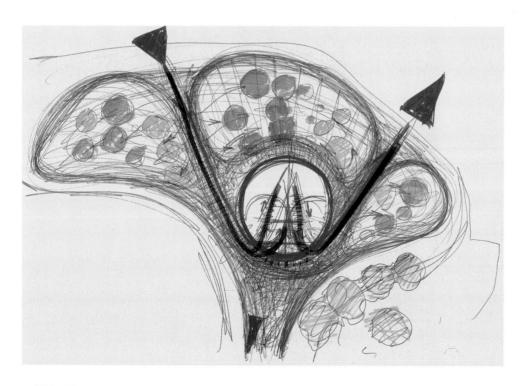

Future Systems
Villa (detail)
Model
H 42 cm

Sir Michael Hopkins CBE RA (Hopkins Architects)
British Antarctic Survey Halley VI Research Station
Model
H 35 cm

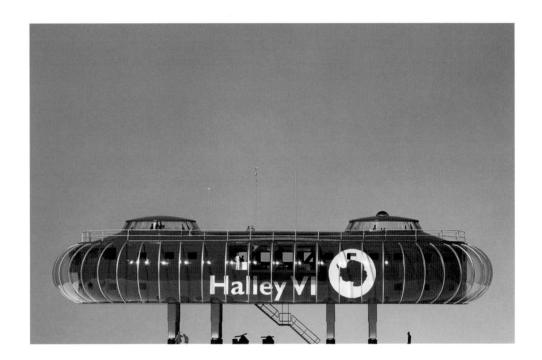

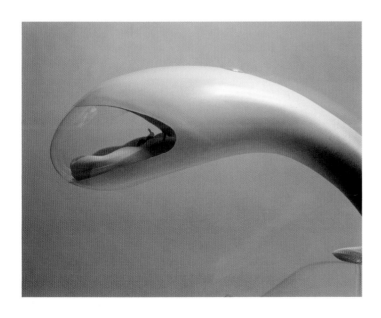

Eva Jiricna CBE RA
(Eva Jiricna Architects)
Private Residence, Prague (detail)
Backlit transparency
95 × 70 cm

Howard Raggatt
(Ashton Raggatt McDougall)
Perth Arena
Digital print
150 × 100 cm

Tadao Ando HON RA
(Tadao Ando Architect & Associates)
4 x 4 House
Photograph
118 × 84 cm

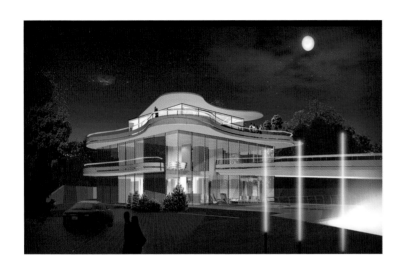

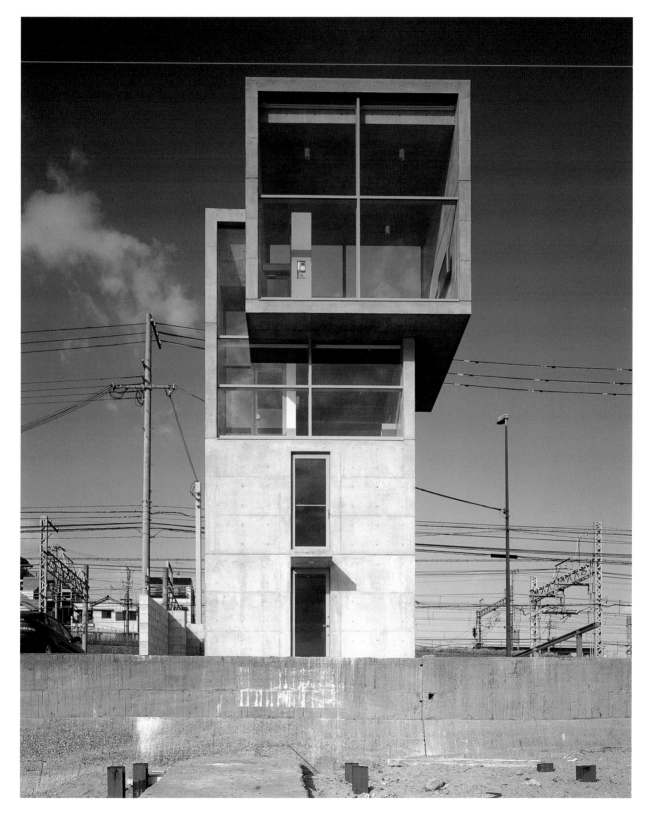

**Sir Richard MacCormac CBE RA
(MacCormac Jamieson Prichard)**
Ideas for Country Houses (detail)
Digital print
40 × 45 cm

Theverymany
A(n)Y_001 (detail)
Digital print
120 × 84 cm

Prof Trevor Dannatt RA (Dannatt Johnson Architects)
Royal Botanic Gardens, Kew.
The Victoria Gate Expansion and Remodelling (detail)
Mixed media
54 × 52 cm

Paul Koralek CBE RA
(Ahrends Burton Koralek Architects)
Tipperary County Council Civic Offices (detail)
Photograph
61 × 118 cm

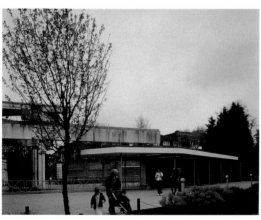

Prof Ian Ritchie CBE RA (Ian Ritchie Architects)
Purfleet Future Housing
Etching
39 × 49 cm

Itsuko Hasegawa
The Capital Plaza International Design Competition, Taipei
Photograph
103 × 37 cm

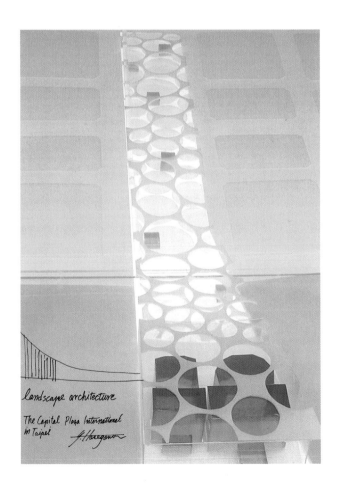

Prof Peter Cook RA
Oslo: Eastern Patch Elevation (detail)
Mixed media
60 × 125 cm

Michael Manser CBE RA (The Manser Practice)
New British Embassy and Offices for DFID in Harare (detail)
Pencil and ink
59 × 84 cm

Toyo Ito & Associates, Architects and TAISAI
Mikimoto Ginza 2
Model
H 19 cm

Leonard Manasseh OBE RA
Bellalux
Ink
10 × 6 cm

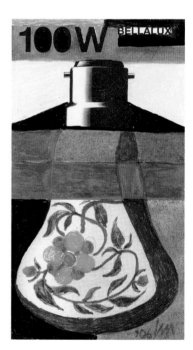

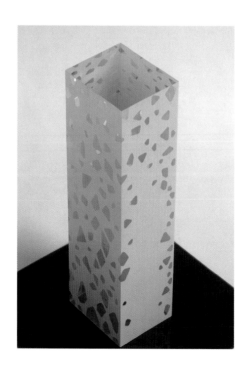

Prof William Alsop OBE RA
Yonkers Powerhouse
Mixed media
180 × 310 cm

Chris Wilkinson RA (Wilkinson Eyre Architects)
Study Model for Tower
Model
H 120 cm

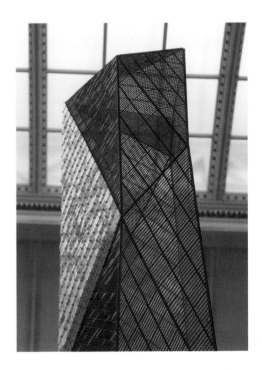

Prof Gordon Benson OBE RA (Benson Forsyth LLP)
Four Projects – Sydney (detail)
Digital photograph
104 × 118 cm

Peter Barber Architects Ltd
The Downybrook Quarter
Inkjet
99 × 162 cm

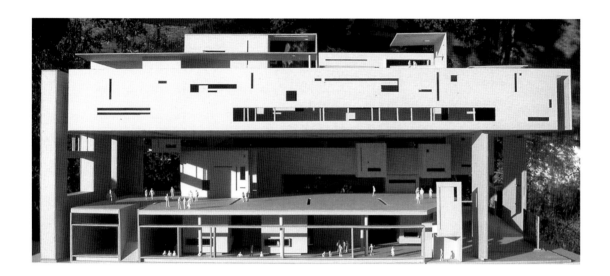

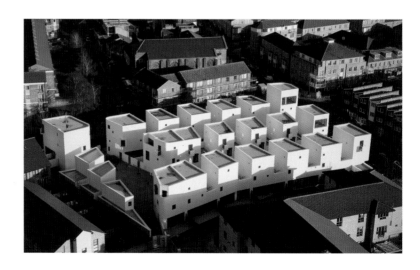

Zaha Hadid CBE RA (Zaha Hadid Architects)
Phaeno Science Centre, Wolfsburg
Photograph
48 × 46 cm

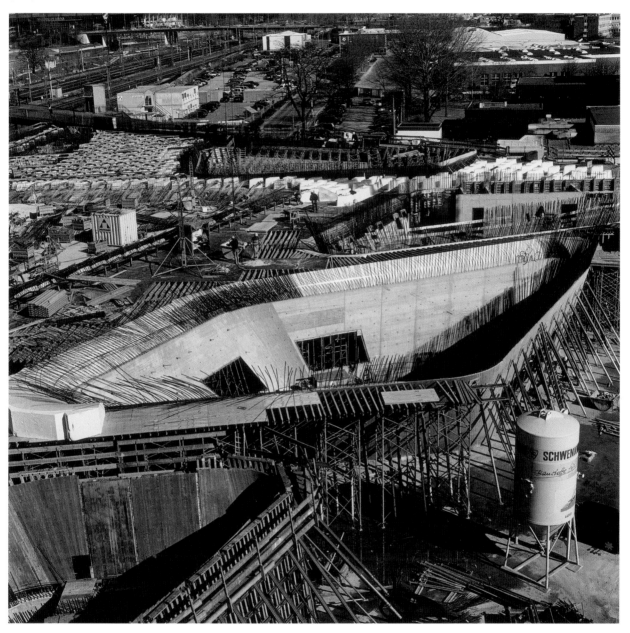

VII

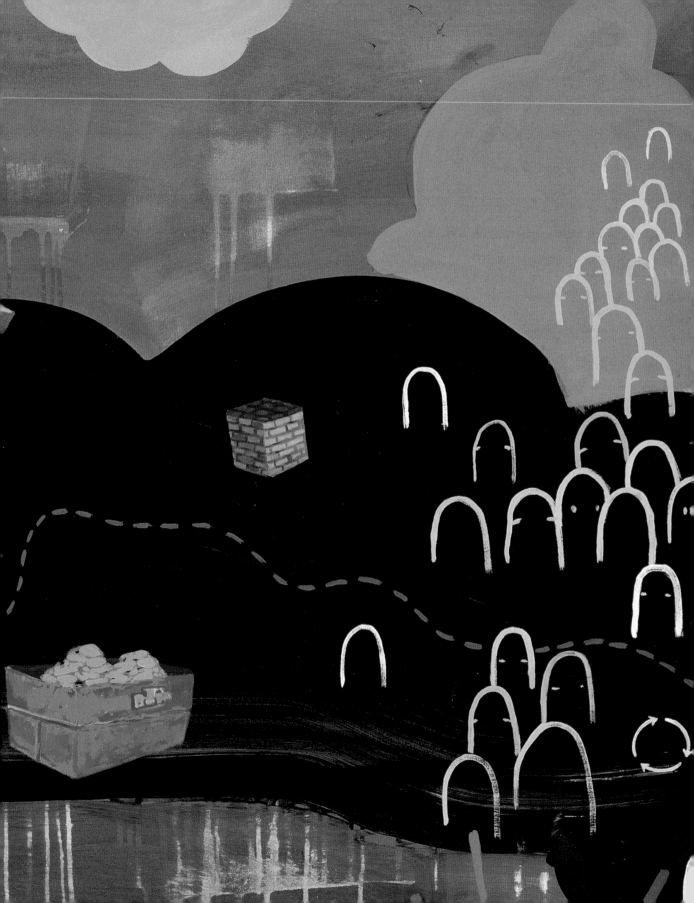

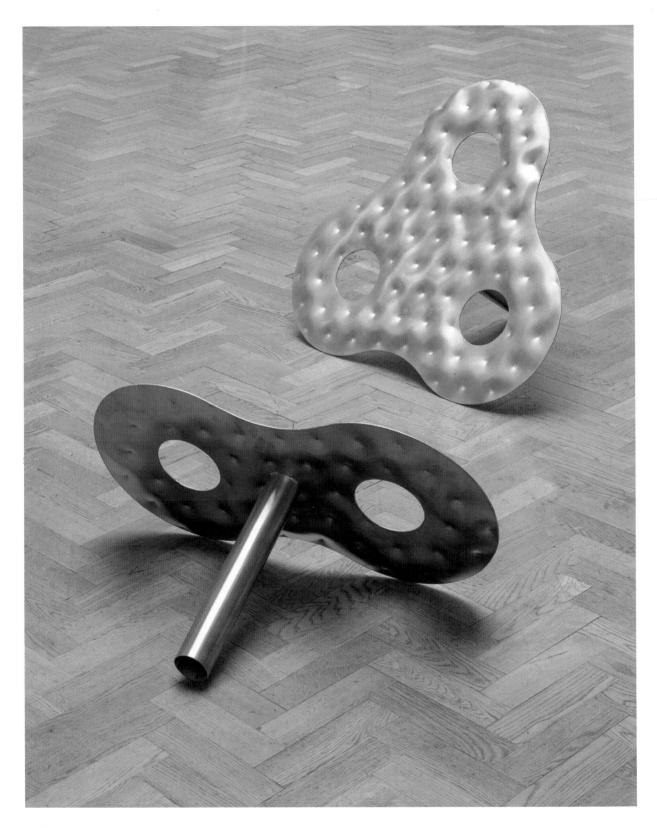

Richard Deacon CBE RA
Infinity
Stainless steel
H 60 cm

John Gibbons
Song (of the Angels) 2003–2004
Stainless steel
H 46 cm

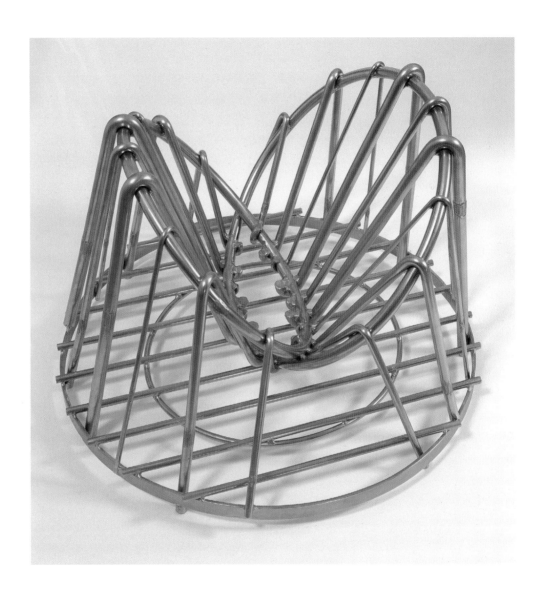

Paul Winstanley
Man Watching TV 4
Oil
136 × 173 cm

Frank Bowling RA
Homage (1934–2005)
Acrylic
32 × 62 cm

Lucinda Oestreicher
Tin Barn
Oil
67 × 81 cm

Daniel Bell
Throb
Pencil
38 × 48 cm

Jordan Dunlop
The Act of Walking
Oil
115 × 170 cm

Paul Becker
Moonbear
Oil
26 × 34 cm

Amy Marie Gladding
Baby, baby, baby
Ink
69 × 94 cm

Neville Weston
Out Back Jack: The Drover's Dog
Oil
76 × 100 cm

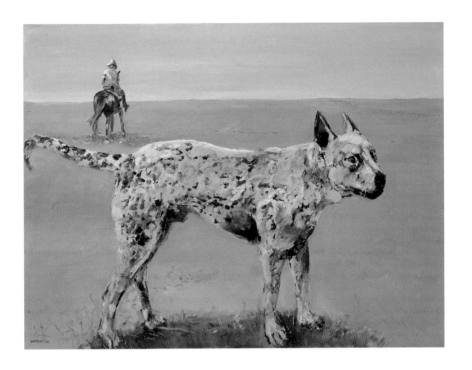

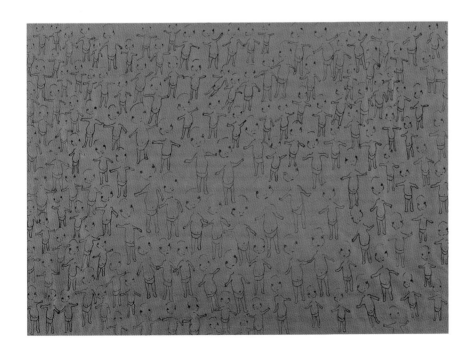

Vic Reeves
Darwin Jones and His Bloodhounds
Acrylic
58 × 40 cm

Miranda Argyle
One Hundred and Forty Thousand Hairs
Silk thread on linen
55 × 61 cm

David Small
Untitled
Oil
45 × 40 cm

Anthony Whishaw RA
Silent Interior 2001/2005
Acrylic
107 × 107 cm

Sonia Lawson RA
Siena II
Oil
112 × 90 cm

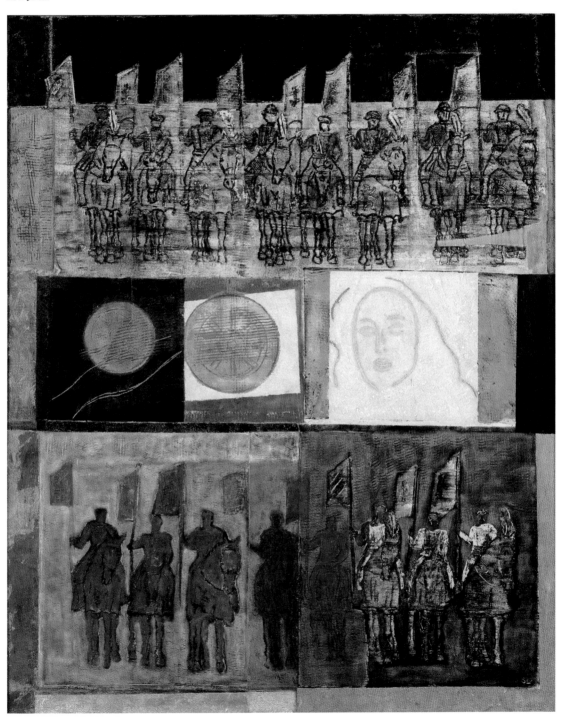

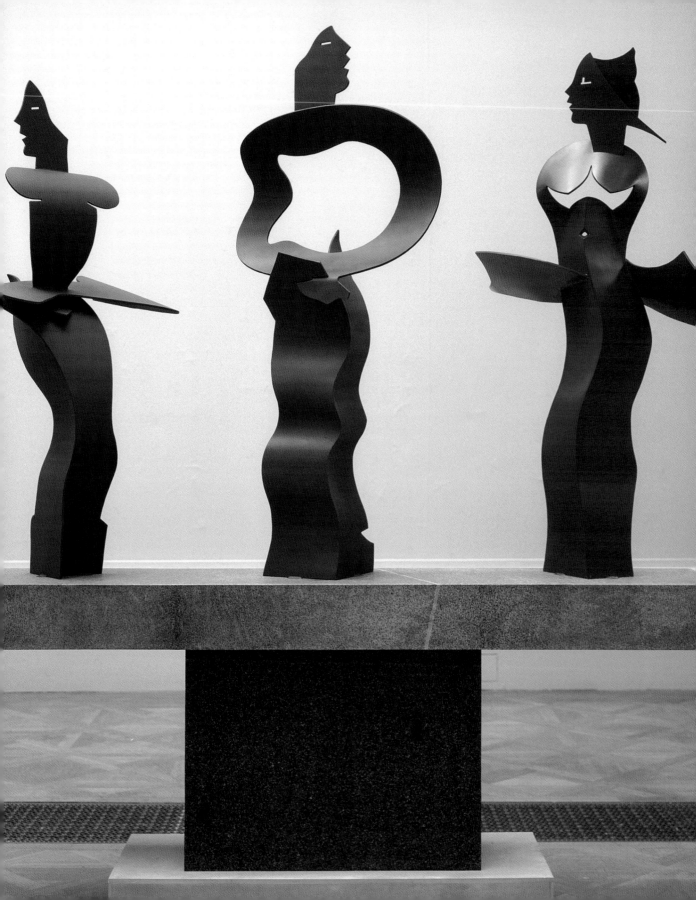

Artist
Title
Medium
~~Dimensions~~

Caroline Gorick
Vanessa
Oil and gloss
130 × 79 cm

Marco Livingstone
Tattooed Dave (Land of Nod)
Pastel
67 × 48 cm

Mimmo Paladino HON RA
Nude Che Scende le Scale No.XI
Watercolour
35 × 50 cm

R B Kitaj RA
Abraham's God After Rembrandt 2005–2006
Oil
123 × 120 cm

Joe Tilson RA
Conjunction, Fichi, Cipresso
Mixed media
56 × 76 cm

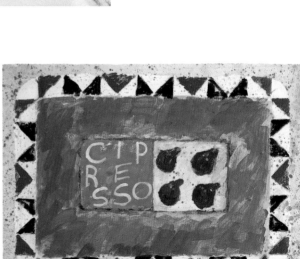

Gus Cummins RA
Annex
Painted steel
H 186 cm

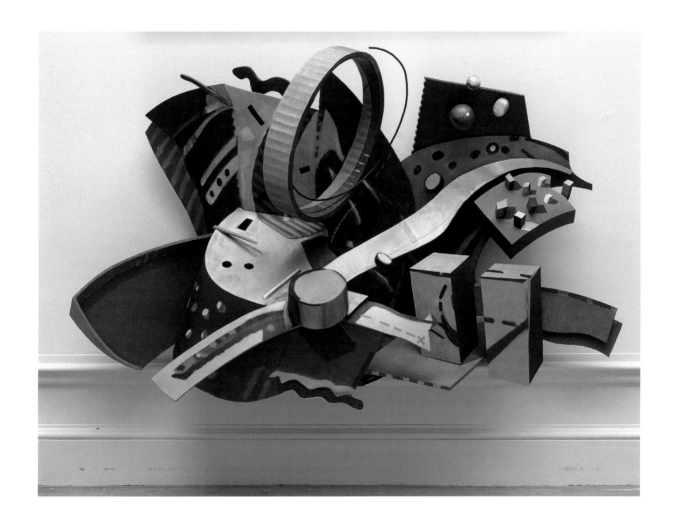

Basil Beattie
Once Upon a Time
Oil and wax
213 × 198 cm

Julian Schnabel
Billy's First Portrait of God
Mixed media
175 × 150 cm

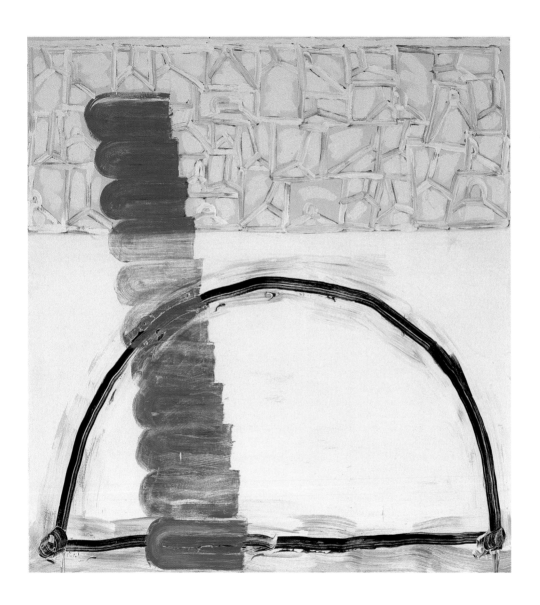

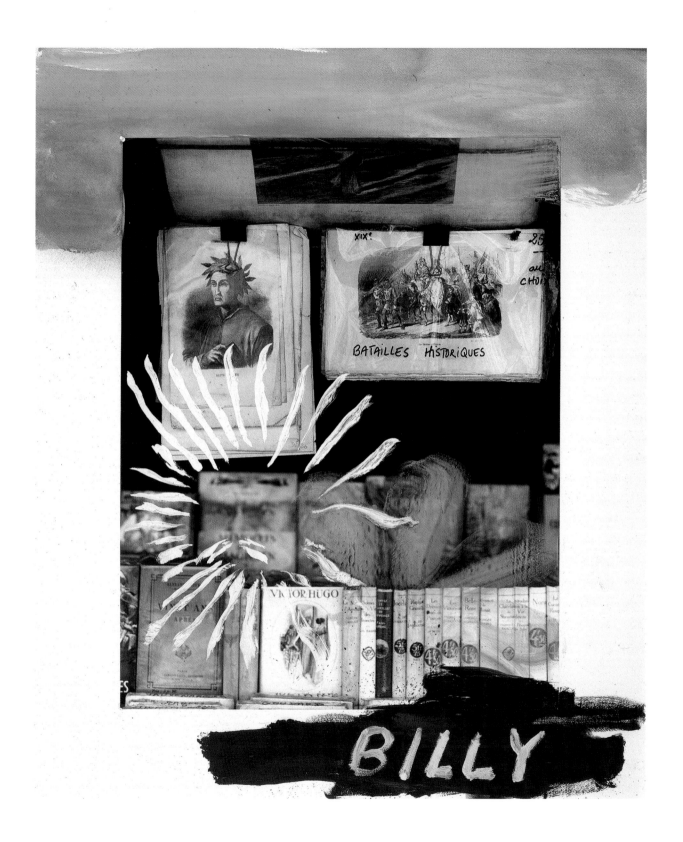

Gabriel Hartley
Untitled
Oil
243 × 243 cm

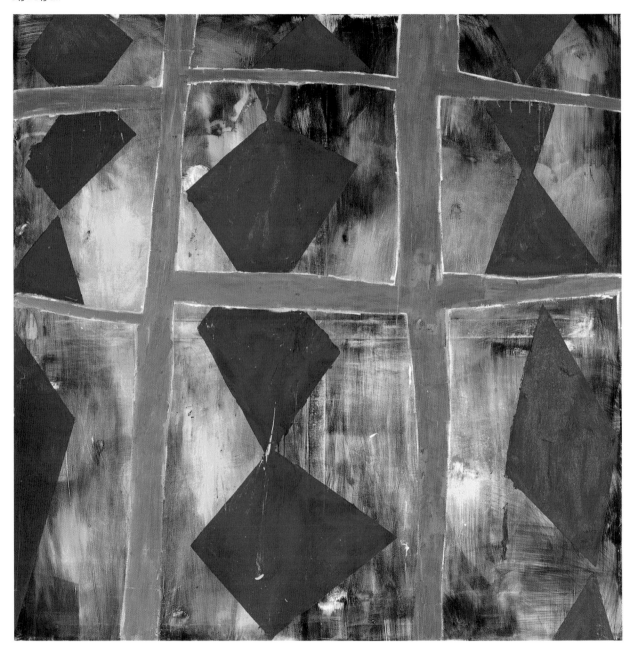

Michael Kidner RA
Creationism?
Colour pencil
280 × 188 cm

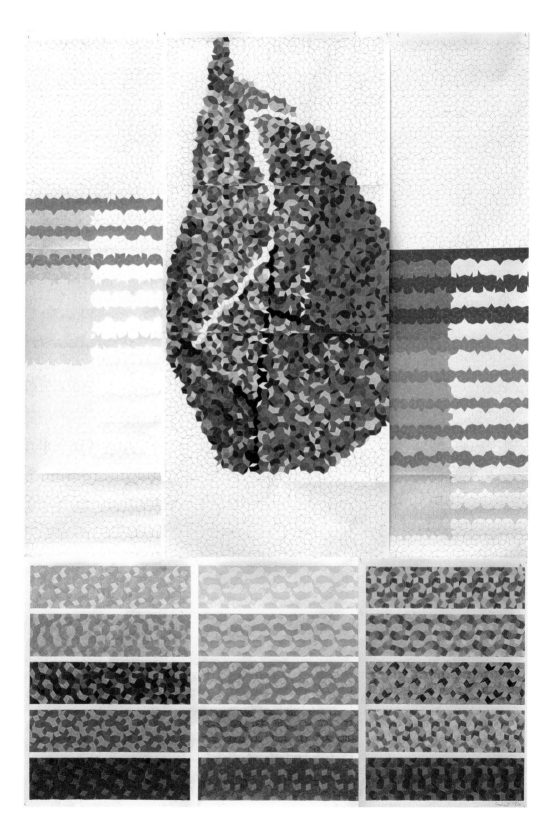

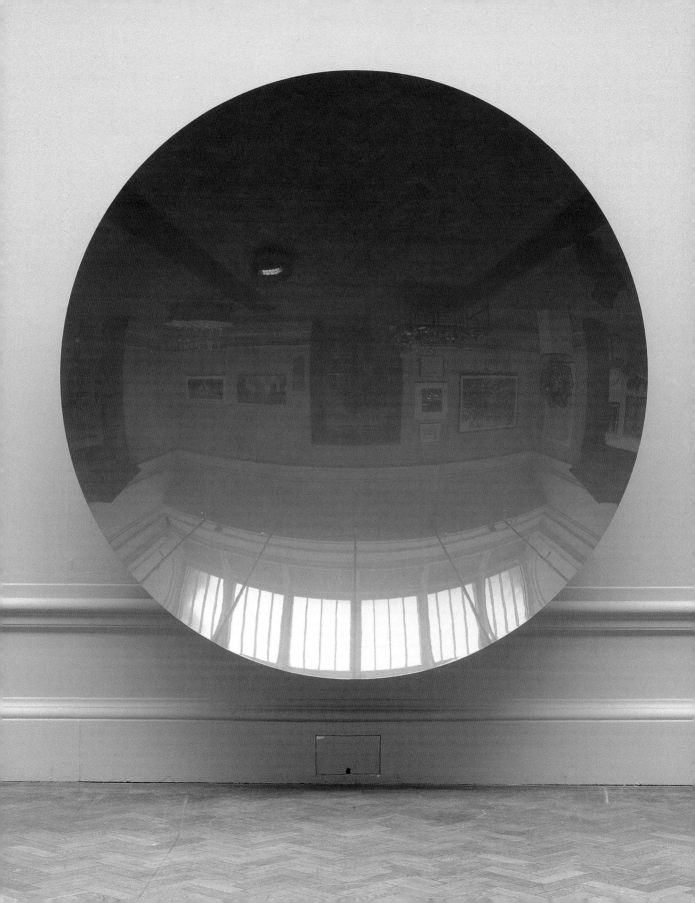

Boyd and Evans
California Norfolk 2004
Photographic inkjet print
60 × 150 cm

Catherine Yass
Split Sides: ¹⁄₄s, 23, 0mm, 15mp
Inkjet print
78 × 158 cm

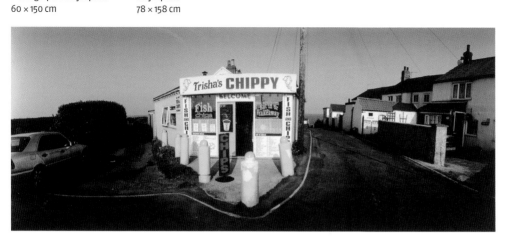

Ralph Brown RA
Relief. Lovers III
Nickel–plated aluminium
65 × 59 cm

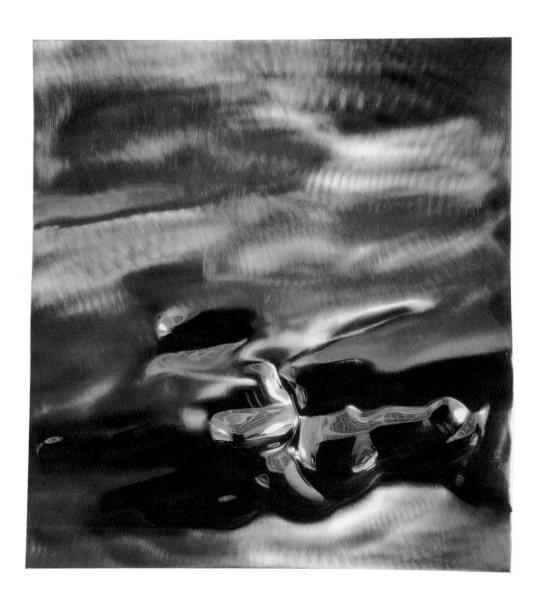

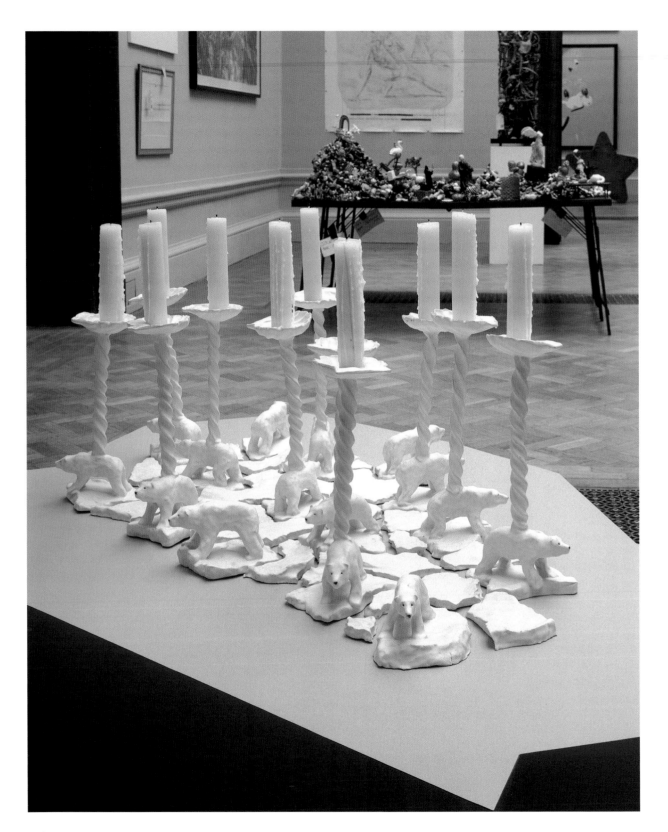

Bill Woodrow RA
Arctic Dreams
Ceramic, MDF, Was
H 98 cm

Sir Anthony Caro OM OBE RA
Polyphemus
Steel and cast iron
H 190 cm

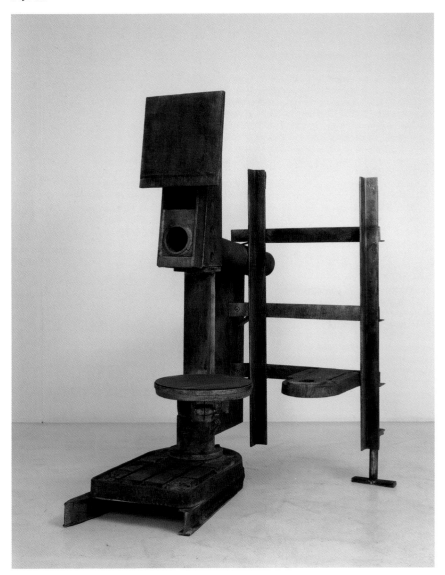

LECTURE ROOM

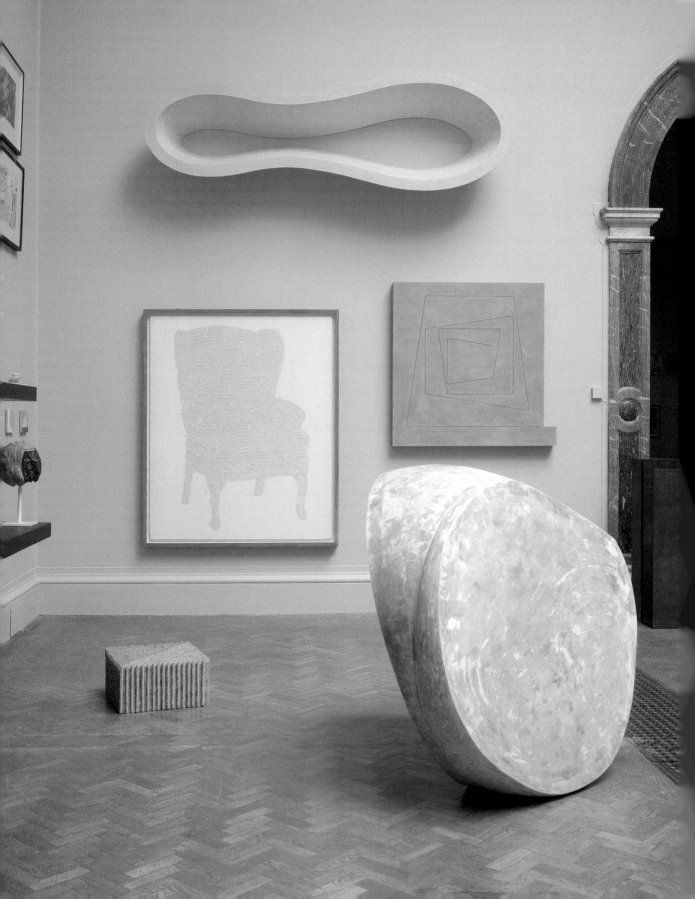

Prof David Mach RA
Heirs and Graces
Collage
190 × 190 cm

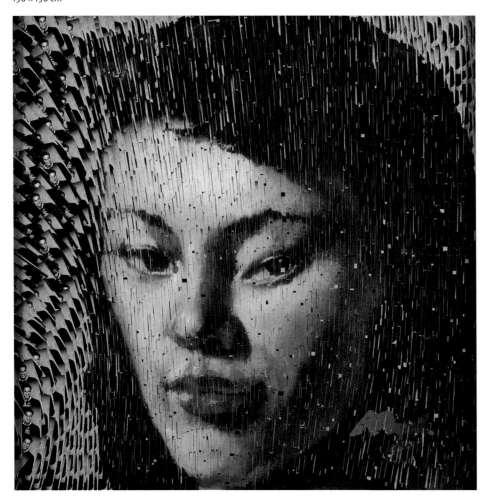

Prof Michael Sandle RA
Study for Godred Crovan, Version II
Watercolour
149 × 100 cm

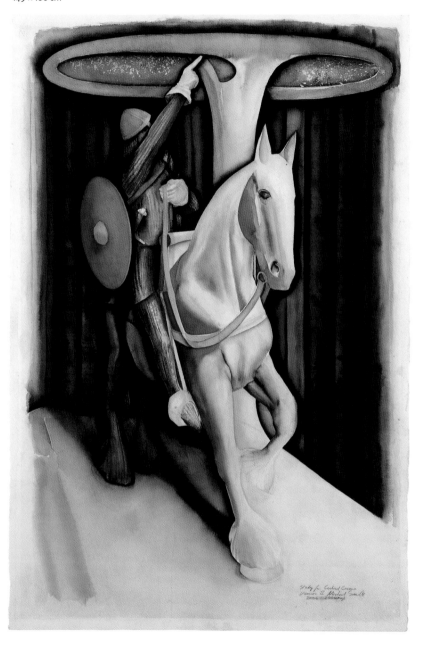

Antoni Tàpies HON RA
Relleu i Collage
Mixed media
53 × 73 cm

Ian Davenport
Three Arches (Blue)
Screenprint
75 × 75 cm

Richard Long RA
River Avon Mud Fingerprints on River Avon Driftwood
Mud and driftwood
170 × 8 cm

Grant Watson
Untitled
Encaustic on jute
40 × 40 cm

Robert Clatworthy RA
Head IV
Acrylic
36 × 25 cm

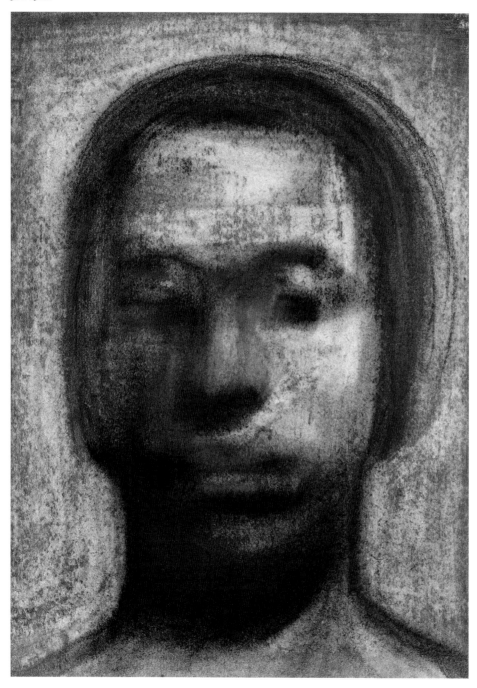

Teo San Jose
Firebird
Steel and enamel
H 170 cm

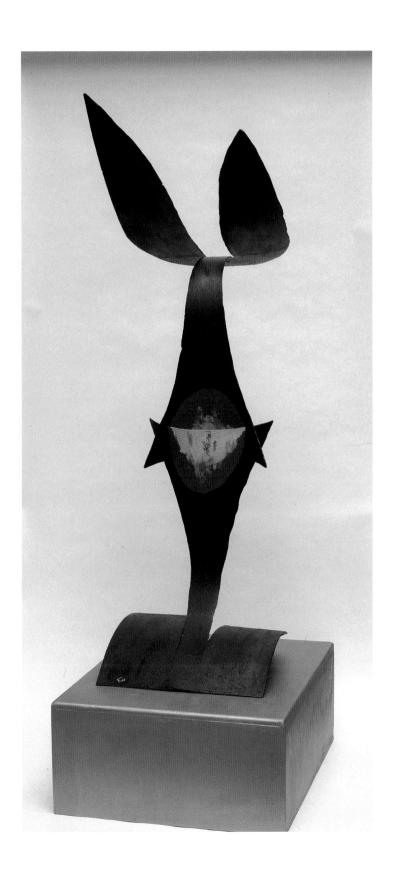

Vincent Jackson
Birch Bark Canoe
Wood and rubber
32 × 420 cm

Ann Christopher RA
The Power of Place – 9
Mixed media/digital image collage
35 × 20 cm

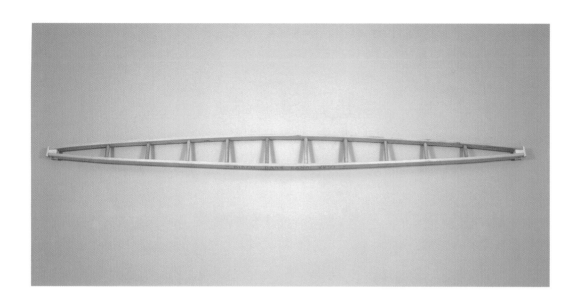

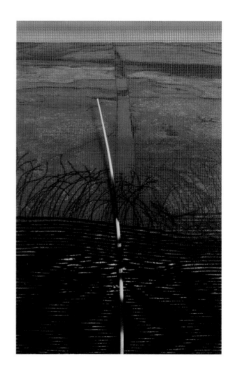

Anya Gallaccio
Untitled 2005
Glass
H 22 cm

Sam Porritt
Untitled (Floor Piece)
Wood
H 27 cm

Geoffrey Clarke RA
Consignment
Aluminium and wood
H 320 cm

John Cobb
Batten Up (VIII)
Beech
H 46 cm

WOHL
CENTRAL
HALL

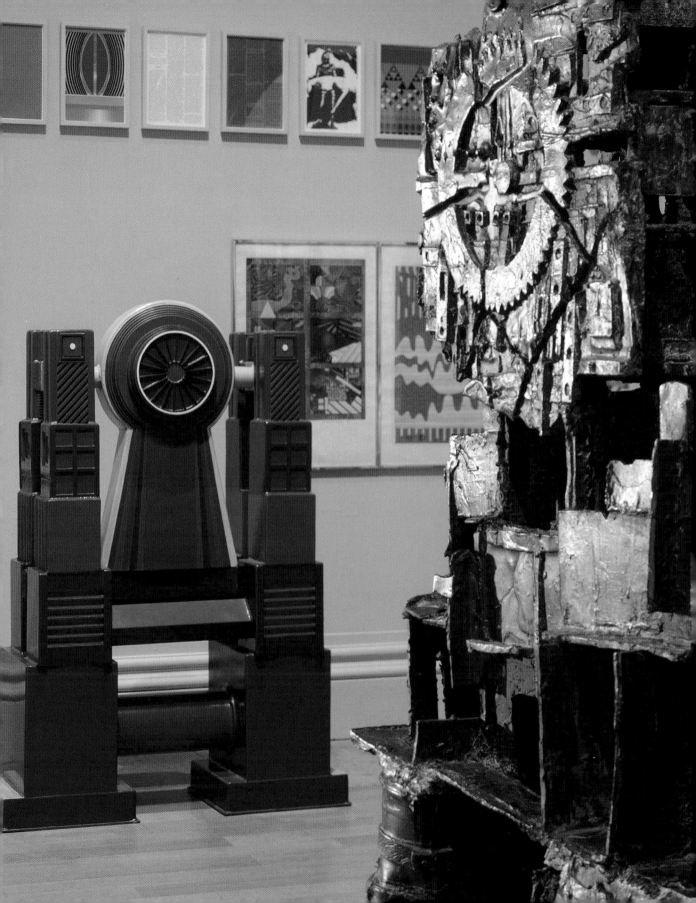

The Late Prof Sir Eduardo Paolozzi CBE RA
Moonstrips Empire News
From the series of 100 colour
lithographs and screenprints
Each 38 × 38 cm

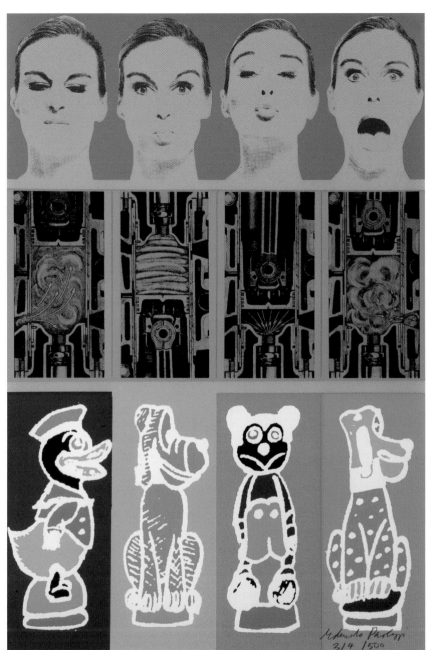

The Late Prof Sir Eduardo Paolozzi CBE RA
As Is When: He Must, so to Speak, Throw Away the Ladder
Screen print
99 × 66cm

The Late Prof Sir Eduardo Paolozzi CBE RA
As Is When: Wittgenstein in New York
Screen print
99 × 66cm

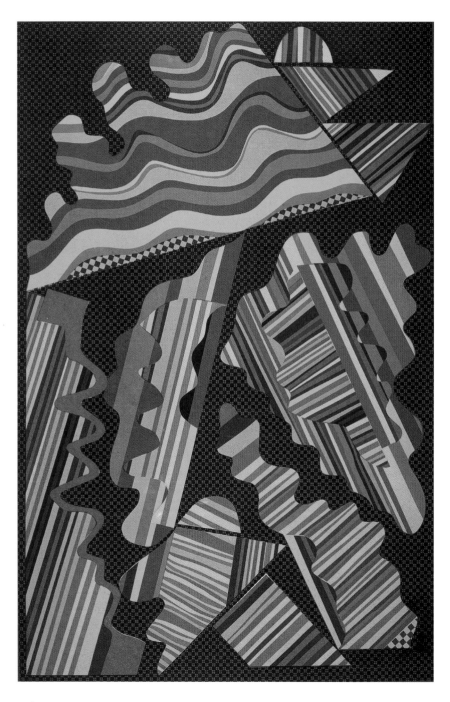

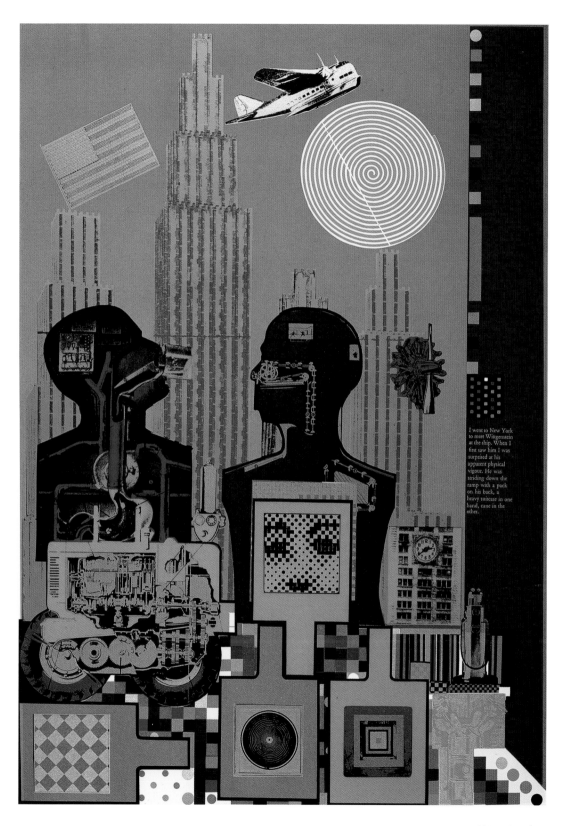

I went to New York to meet Wittgenstein at the ship. When I first saw him I was surprised at his apparent physical vigour. He was striding down the ramp with a pack on his back, a heavy suitcase in one hand, cane in the other.

The Late Prof Sir Eduardo Paolozzi CBE RA
Table Sculpture (Growth)
Bronze
H 80 cm

The Late Prof Sir Eduardo Paolozzi CBE RA
His Majesty the Wheel
Bronze
H 183 cm

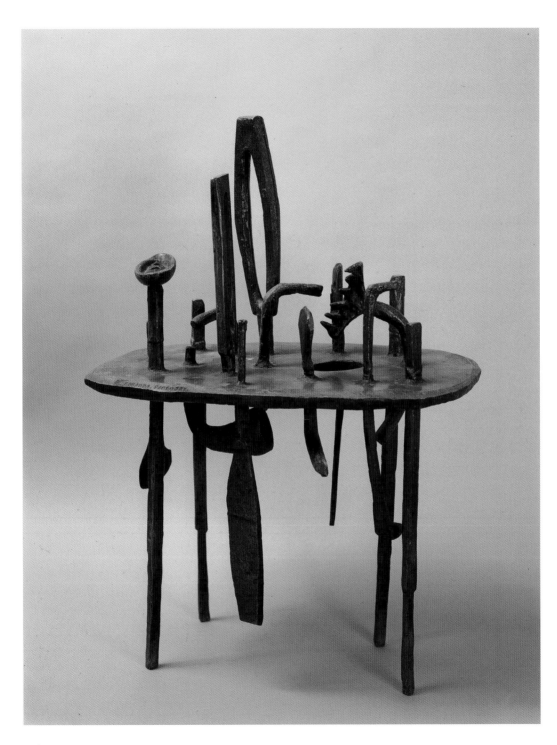

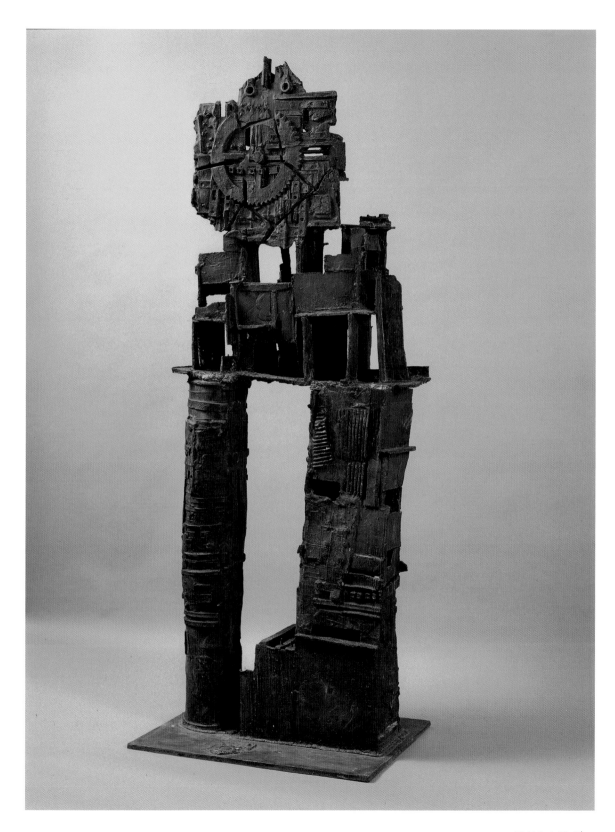

Marcus Harvey
Toilet Roll
Oil
100 × 100 cm

Karoline Hjorth
Siri (from the series In Your Face)
Photograph
101 × 76 cm

Prof Gary Hume RA
Hermaphrodite Polar Bear
Silkscreen
60 × 47 cm

Petros Chrisostomou
Untitled No. 1
Photography and mixed media
26 × 16 cm

Richard Wilson RA
Butterfly (model)
Card, spraypaint on paper
H 16 cm

Ed Ruscha HON RA
Bound in Boiler Iron
Acrylic on paper
76 × 102 cm

Alison Wilding RA
Muffle
Alabaster and silk
H 13 cm

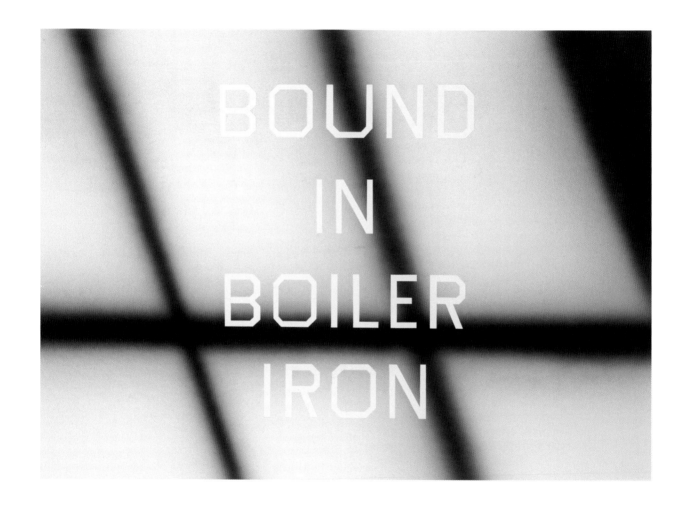

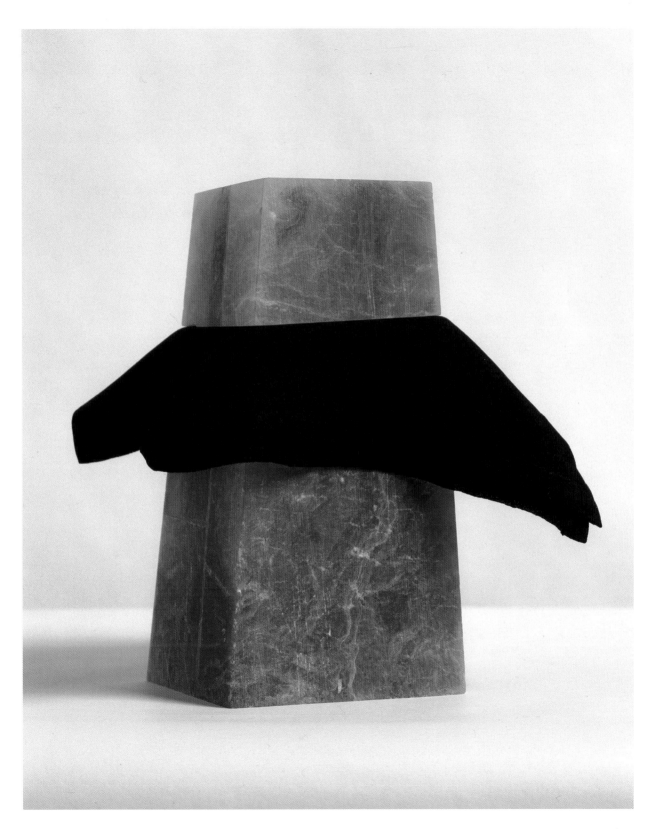

Index

Royal Academy Trust

Registered charity number 1067270

The Royal Academy of Arts has a unique position as an independent institution led by eminent artists and architects whose purpose is to promote the creation, enjoyment and appreciation of the visual arts through exhibitions, education and debate. The Royal Academy receives no annual funding via the government, and is entirely reliant on self-generated income and charitable support.

You and/or your company can support the Royal Academy of Arts in a number of different ways:

- £60 million has been raised for capital projects, including the Jill and Arthur M Sackler Wing, the restoration of the Main Galleries, the restoration of the John Madejski Fine Rooms, and the provision of better facilities for the display and enjoyment of the Academy's own Collections of important works of art and documents charting the history of British art.
- Donations from individuals, trusts, companies and foundations also help support the Academy's internationally renowned exhibition programme, the conservation of the Collections and educational projects for schools, families and people with special needs; as well as providing scholarships and bursaries for postgraduate art students in the RA Schools.
- Companies invest in the Royal Academy through arts sponsorship, corporate membership and corporate entertaining, with specific opportunities that relate to your budgets and marketing/entertaining objectives.

- A legacy is perhaps the most personal way to make a lasting contribution, through the Trust endowment fund, ensuring that the enjoyment you have derived is guaranteed for future generations.

To find out ways in which individuals, trusts and foundations can support this work (or a specific aspect), please contact Sharon Maurice on 020 7300 5637 to discuss your personal interests and wishes.

To explore ways in which companies can be come involved in the work of the Academy to mutual benefit, please telephone Joanna Conlan on 020 7300 5620.

To discuss leaving a legacy to the Royal Academy of Arts, please telephone Sally Jones 020 7300 5677.

Membership of the Friends

Registered charity number 272926

The Friends of the Royal Academy was founded in 1977 to support and promote the work of the Royal Academy. It is now one of the largest such organisations in the world, with around 91,000 members.

As a Friend you enjoy free entry to every RA exhibition and much more…

- Visit exhibitions as often as you like, bypassing ticket queues
- Bring an adult guest and four family children, all free

- See exhibitions first at previews
- Keep up to date through RA Magazines
- Have access to the Friends Rooms

Why not join today

- Onsite at the Friends desk in the Front Hall
- Online on www.royalacademy.org.uk
- Ring 020 7300 5664 any day of the week

Support the foremost UK organisation for promoting the visual arts and architecture – which receives no regular government funding. *Please also ask about Gift Aid.*

Summer Exhibition Organisers
Chris Cook
Edith Devaney
Tanya Millard
Katherine Oliver
Paul Sirr
Genevieve Webb
Gillian Westgate

Royal Academy Publications
David Breuer
Harry Burden
Claire Callow
Carola Krueger
Peter Sawbridge
Nick Tite

Book design: 01.02
Photography: FXP and John Riddy
Colour reproduction: DawkinsColour
Printed in Italy by Graphicom

British Library
Cataloguing-in-publication Data
A catalogue record for this book
is available in the British Library

ISBN 1-903973-76-7

Illustrations
Page 2: Sandra Blow RA, *Blue and White Collage* (detail)
Pages 4–11: Artists in their studios working on their submissions for the Summer Exhibition
Page 4: Prof Norman Ackroyd RA; Page 6: Prof Peter Cook RA; Page 8: Keith Wilson; Page 10: Humphrey Ocean RA
Page 12: Damien Hirst, *The Virgin Mother*
Page 15: Ann-Caroline Breig, *Sex and the City* (detail)
Page 21: Sir Anthony Caro OM CBE RA, *South Passage*
Page 29: Anthony Eyton RA, *Cherry Blossom* (detail)
Page 39: Prof Christopher Le Brun RA, *Rider* (detail)
Page 61: Katie Jones, *Friendly Jostle* (detail)
Page 73: Stephen Chambers RA, The Island (with Constant Chaos) *(detail)*
Page 91: The Late Patrick Caulfield CBE RA, *Villa Plage* (detail)
Page 99: Richard Wentworth; *Fort (For Marie Antoinette)* (detail)
Page 113: Sir Nicholas Grimshaw CBE PRA, *View above the main entrance to the Caixa Galicia Art Foundation*
Page 127: Jordan Dunlop, *The Act of Walking* (detail)
Page 141: Allen Jones RA, *Banquet*
Page 151: Anish Kapoor CBE RA, *Untitled 2006*
Page 157: top, Nigel Hall RA, *In the Bergell (Stampa)*; in the fore ground, Gereon Krebber, *Banana Stub*
Page 171: The Late Prof Sir Eduardo Paolozzi CBE RA, left: *Wittgenstein at Cassino*; right: *Her Majesty the Wheel*
Page 179: Tom Phillips RA, *From Life: Song of Myself* (detail)
Page 181: in the foreground, Gavin Turk, *Hare Egg*